IMAGES of America
LEXINGTON

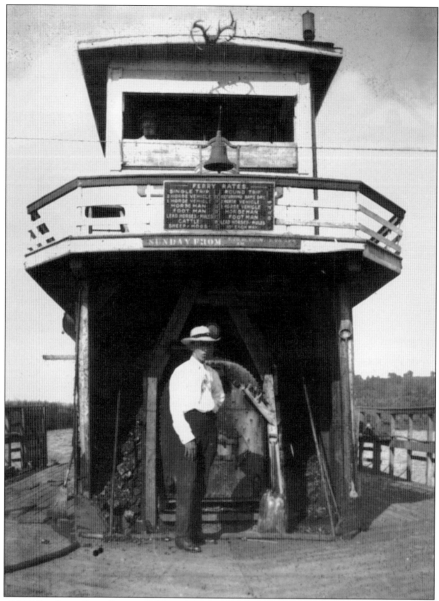

Around 1900, when this photograph was taken, this steam-powered ferry crossed the Missouri River about every hour during daylight hours. The captain stands proudly, high up to the left of the antlers and the bell, with his rates posted below him—from 15¢ to 75¢. The young man below him must have put on his best clothes for the photographer, since the job of shoveling coal was a hot and dirty one. (Courtesy of the Lexington Historical Association.)

On the Cover: Apples were picked and put in barrels for shipment by train in the 1920s. This was, and still is, backbreaking manual labor, which is now mostly done by migrant workers. The ladies in the photograph seem to be there in order to pose for the photograph. There are several apple and peach orchards in the Lexington area, the largest of which is Rasa Brothers Orchards, about eight miles east of town. An Apples, Arts, and Antiques Festival is held each fall. (Courtesy of the Lexington Historical Association.)

Roger E. Slusher and the
Lexington Historical Association

Copyright © 2013 by Roger E. Slusher and the Lexington Historical Association
ISBN 978-1-4671-1033-4

Published by Arcadia Publishing
Charleston, South Carolina

Printed in the United States of America

Library of Congress Control Number: 2013932420

For all general information, please contact Arcadia Publishing:
Telephone 843-853-2070
Fax 843-853-0044
E-mail sales@arcadiapublishing.com
For customer service and orders:
Toll-Free 1-888-313-2665

Visit us on the Internet at www.arcadiapublishing.com

To Sandy, whose love and support keep me going

CONTENTS

Acknowledgments		6
Introduction		7
1.	Trails and Trade	11
2.	Conflict, Hemp Bales, and Jesse James	25
3.	Railroads and Coal Mines	33
4.	Victorian Times	49
5.	Height of Prosperity	77
6.	Depression and Recovery	107
Bibliography		126
Index		127

Acknowledgments

In 1955, at the age of eight, I got the history bug when my family took two wonderful vacations. First, we rode a train to visit my maternal grandparents in Hartford, Connecticut, where I saw the Mark Twain House. Then, we toured New York City to see sites like the Empire State Building and the Statue of Liberty. Later that summer, we drove to Montana to visit my father's brother Edward, a forest ranger who lived in a log house in the mountains. Add in horses and three children our age, and you can imagine that we were in heaven. Seeing Mount Rushmore and Yellowstone Park on the way were also very memorable.

In compiling this book, I received special help from several people. Mary Katherine Wilcoxon Gooseman inspired me with her huge collection of photographs and great knowledge of recent Lexington events. Susan Worthington and Fred and Abigail Tempel were kind enough to read my manuscript, point out errors, and make useful suggestions. My acquisitions editor at Arcadia Publishing, Liz Gurley, has been very kind and helpful in getting me through the process of preparing this book for publication. However, any errors are mine, and I always appreciate getting new information.

Finally, I want to thank the board members of the Lexington Historical Association for allowing me to use their fine collection of photographs, mostly collected by sheriff and fire chief Karl Hammer. All of them, especially Tom Butler, were helpful in answering my questions or in giving me moral support.

Unless otherwise noted, all images in this book were graciously provided by the Lexington Historical Association.

INTRODUCTION

In the 1800s, as Americans were moving westward along the Missouri River valley, Lexington grew into a regional business and cultural center. The earliest settlers mostly came from the Upper South. Gilead Rupe and his family arrived in 1815, and, despite a serious Indian attack, he survived and prospered. He was soon followed by his nephew, a government surveyor named James Hicklin. The first land purchase was made in 1819 by Wilson Owen, whose partner, William Jack, set up a ferry that same year.

In 1822, the Lillard (now Lafayette) County Court platted a new county seat near those settlers. Likely named after Lexington, Kentucky, it was about two miles from the river, in the area now known as Old Town. The first major business was the store and warehouse of John Aull, who was joined in 1825 by his brothers Robert and James. The Aull brothers soon operated four stores, a hemp ropewalk, flour and lumber mills, and an informal bank in the area. Although the majority of their customers were local settlers, they also supplied fur trappers and traders on the Santa Fe Trail, which passed through the town.

In 1836, Finis Ewing, a founder of the Cumberland Presbyterians in Kentucky, came to Lexington as the federal land registrar. A supporter of the temperance movement, he built up his church in the area and freed his slaves. He and James Aull, who in 1835 called for "gradual abolition," were rare public opponents of slavery. The large hemp plantations, as well as many other enterprises in the area, depended on slaves for labor. By the 1840s, most hemp was being baled for shipment to St. Louis, where it was made into burlap for wrapping cotton bales. Mixed farming and tobacco growing were also common.

The 1840s and 1850s brought great prosperity; in 1845, with 1,697 people, Lexington was the third-largest city in Missouri. River traffic was booming with trade and travelers. An article in the *Lexington Intelligencer* notes, "Before the Civil War . . . it was no unusual thing to see six or eight steamboats at our . . . landing." Unfortunately, steamboating could be dangerous, and 10 boats sank at a bend near the city. The greatest tragedy occurred in 1852, when about 100 Latter-day Saints and their crew died in the explosion of the *Saluda*.

The prosperity of that era led to many changes. In 1836, New Town was platted near the river, around a square where the present Greek Revival courthouse was built in 1847. Most denominations, starting with the Presbyterians in 1844, built new brick churches in the area. In 1847, the Masonic College, for male orphans of Masons, was constructed, as well as the Fifth Branch of the State Bank.

The first public school opened in 1829, but there was no public high school until 1871. A series of private schools also operated in the area, and, in 1850, the Baptist Female Collegiate Institute was started in the old courthouse. It was joined by the Presbyterian Elizabeth Aull Seminary in 1859 and the Methodist Central College for Women in 1871.

Working as carpenters, masons, saddlers, blacksmiths, and wagonmakers, and founding creameries, canneries, flour mills, and grain elevators, German immigrants diversified the economy. The most prominent German business was the Winkler Furniture Company, founded by Henry

and Frederick Winkler in 1870. Soon, it employed up to 55 men, making it the largest furniture company west of St. Louis.

During the Mexican-American War, in 1846, a Lafayette County company served under Col. Alexander Doniphan, who had earlier practiced law in Lexington. After it helped occupy Santa Fe, Colonel Doniphan's unit headed for Chihuahua and overtook a caravan of Santa Fe traders that included James Aull. After the town was captured, Aull set up a store, but he was killed by bandits in 1847.

Meanwhile, by 1849, William H. Russell, who had started working for the Aull brothers in 1830 and was in partnership with Lexington merchant William Bradford Waddell and others, shipped 600,000 pounds of supplies to Santa Fe for the Army. In 1858, he and Waddell joined Alexander Majors of Westport in getting the government's consolidated contract for all western forts. Operating out of various frontier towns, with their headquarters at Lexington, they did very well at first, but their Pony Express failed to win the mail contract for their stage line, and they went out of business in 1861.

In the 1850s, some Lexington men were voting and fighting to make Kansas a slave state. In 1860, there were 6,374 persons held in slavery in Lafayette County, the most of any county in Missouri. Those slaves helped produce a record 4,604 tons of hemp that year. In the 1860 presidential election, Lexington natives, wanting to stay in the Union but keep slavery, mainly voted for the Constitutional Union Party and Abraham Lincoln only got 13 votes.

When the Civil War began, the community was divided, and most people hoped to stay out of the war. Those hopes were dashed in the summer of 1861, when about 3,000 Federal troops under Col. James Mulligan of Chicago's Irish Brigade fortified the then vacant Masonic College campus as part of the Union effort to hold the Missouri River valley. In September, they were surrounded by almost 20,000 pro-Confederate State Guard troops under Gen. Sterling Price. After three days of fighting, especially over the former home of Col. Oliver Anderson, General Price used hemp bales for moving breastworks to force a Union surrender. He soon retreated south, however, and the town was occupied off and on by Federal troops, who contended with pro-Southern bushwhackers until they left in July 1865.

The end of the war and slavery brought huge changes to the community. In a March 1867 letter to his uncle James Hicklin, James Ware, of Kentucky, writes, "[I] was truly sorry to hear of your troubles and misfortunes, but Uncle Jim if I only had a home I would be satisfied but I have not a place to lay my head which I can call my own . . . If I live I will pay you what I owe you." It was an even newer world for freed slaves. Many of them left the area, while others continued to work for their former masters or for the new railroads and coal mines. Separate schools for African Americans were started as early as 1867. Several substantial churches were built, and some black businesses, such as the Gem Barbershop, which opened in 1880, were begun.

Unfortunately, the bitterness of the war did not end quickly. In April 1865, Jesse James was shot by Federal troops while riding toward Lexington with a group of bushwhackers to surrender. In October 1866, he and three other young men took $2,000 from the Alexander Mitchell Bank. In 1868, a railroad connected Lexington to the Hannibal & St. Joseph line at a depot on the north side of the Missouri River. In September 1874, as the omnibus traveled from the depot to the ferry, it was robbed by the James-Younger Gang. The men only got about $275—and a scolding from one of the passengers, who knew them. One of the other passengers happened to be James Lane Allen, who was coming to teach in Lexington and went on to become a famous Kentucky novelist.

In 1871, the Lexington & St. Louis Railroad completed a line from Sedalia to Lexington; in 1876, a narrow gauge line was completed to Kansas City; and, in 1882, the standard gauge Missouri Pacific line was run along the south side of the Missouri River. With the steamboat and hemp businesses dying, coal became the main industry of the area, for the railroads and many other uses. It was soft coal, and the seam averaged 22 inches. By 1908, there were 46 mines in the county and about 1,700 miners in the Lexington area. Most were from Ireland, France, and Italy, quickly making the Catholic church the largest in town.

Other important businesses in the late 1800s included the Lexington Brewing Company and Ice Plant, the Lexington Brick Company, a gas plant that provided gas lighting by 1881, the Lexington Water Company, and the Lafayette Telephone Company, formed in 1898. In 1880, banker Stephen G. Wentworth founded Wentworth Military Academy, and the Grand Opera House debuted in 1895 with a performance of *Othello*.

Lexington had streetcars pulled by mules from 1884 until 1899, and brick paving of the streets began in 1902. The Santa Fe Trail and Boone's Lick Road Association was formed in Lexington in 1911, and it successfully got that route designated as the first east-west state road.

Social life before World War I was quite varied. Brass bands were popular, and many of them played on the bandstand in the courthouse square. In the summer, Chautauquas and camp meetings were held in the area; in the winter, there were many recitals and concerts at the various schools, as well as entertainment at the Grand Opera House and at several silent movie theaters. The highlight in some years was the Goose Pond Minstrels, a volunteer variety show put on by local businessmen. Originally staged to finance the building of the Goose Pond playing field and swimming pool in 1913, the shows were repeated a few times until 1940.

Because locals had relatives and former countrymen fighting on both sides, World War I was a traumatic event for the community. There were several successful fund drives, especially by the Italian Lodge, since the members' former country was allied with the Americans. A total of 76 young men from the county died in the war, the first of whom was George Cullom of Lexington. James M. Sellers Sr., who was later the president of Wentworth Military Academy, won the Silver Star as a Marine captain in France.

After her husband was killed, along with two other lawmen, by escaping prisoners in 1919, Minnie Mae Talbott was the first woman elected sheriff in the United States.

The 1920s brought many changes. The unsuccessful pontoon bridge built across the river in 1889 and a series of ferryboats were replaced by the Lafayette–Ray County Bridge in 1925. In 1927, the junior-senior high school was completed next to the Goose Pond. Lexington was honored in 1928 when national project chairman and Jackson County judge Harry Truman dedicated the Daughters of the American Revolution's Missouri Madonna of the Trail statue near the new bridge.

In the midst of those events, an illegal operation was prospering just one block from the county jail and courthouse. In 1929, federal agents raided a large distillery in the old brewery. During Prohibition, Lexington and the county were pretty wide open, with roadhouses like the Peckerwood Club west of town and numerous speakeasies, especially on the notorious Block 42, just west of the courthouse. Along with gambling, prostitution, and music from jazz bands, customers from as far away as Kansas City enjoyed the fruits of numerous stills, some of them on islands in the river.

Lexington struggled during the Great Depression, but the farms and mines provided a degree of stability, as did the county farm, to the west of town, for those in desperate need. The Art Deco Lexington Municipal Auditorium and the concrete bleachers in the Goose Pond were built as Works Progress Administration (WPA) projects. There were two movie theaters, and, in 1939, the Dunhill Shirt Company started production.

The construction of Lake City Arsenal about 25 miles to the west provided many new jobs as World War II arrived. Hundreds of men and women enlisted in the services, while thousands bought war bonds, participated in scrap drives, and did what they could to help the war effort. Wentworth Military Academy became a training camp, as it had been in World War I, not only for Army officers but also for groups of Naval Aviation cadets, who got training at the airport across the river. Lexington's most distinguished officer was Gen. William Hoge. His engineering units built the Alcan Highway in 1942, were part of the D-day invasion, and captured the Remagen Bridge in the Battle of the Bulge. He received four stars and commanded American troops in Europe after the war.

In 1942, a new Douglass Elementary and High School was built for African American students from all over the area. In 1950, the Memorial Hospital was dedicated, but 1951 brought a terrible flood and the war in Korea. Business began to grow, led by the Mattingly chain of dime stores,

which was headquartered in town. Radio station KLEX was founded in 1956. Integration came in 1956–1957, and rural districts were unified with the town in 1957 with the opening of the new Bell Elementary School.

In 1959, the state park board took over what is now known as the Battle of Lexington State Historic Site. Although reenactments had been done before, for the 100th anniversary of the battle in 1961, the first of many large reenactments was staged by Wentworth cadets and witnessed by 20,000 spectators.

In 1963, Lexington got its first mall, which featured a new A&P store, and a new post office opened in 1965, leaving the 1912 one vacant. In 1966, Wentworth completed the Wikoff Fieldhouse, and the current high school opened in 1967, soon to be followed by the Lex-La-Ray Votech Center next door. In 1972, the first Matco store was opened in Lexington; after it expanded to include 15 Matco and 35 Mattingly stores, the company was bought by Place's in the 1980s. There was a major sesquicentennial celebration in 1972, about the same time that cable television seemed to bring the world closer.

Meanwhile, the tragedy of the Vietnam War had been brought home by news that Dale Buis, who graduated from Wentworth Military Academy in 1942, was one of the first American soldiers officially killed in the war. In 1971, another former cadet, Bill Adams, was flying a rescue mission when he was shot down and killed, receiving the Medal of Honor. A "Huey" helicopter like the one he was flying was dedicated at Wentworth Military Academy in 1987 as a Vietnam memorial. In 1980, the school celebrated its centennial, with Vice Pres. Walter Mondale as the commencement speaker.

In 1952, the garden club began hosting tours of older homes, which were continued by various groups, with profits going to community projects, most notably the restoration of the 1846 Cumberland Presbyterian Church, which opened as the Lexington Historical Museum in 1976. In the 1980s, many local residents began to restore old homes and stores, leading to a revival in tourism that continues to the present. In 1990, Cindy Dickmeyer became the first female mayor of Lexington, and, in 1992, Community Betterment formed Lexington Pride to encourage the revitalization of downtown with period streetlights and facade loans.

The 1993 flood brought the Missouri River to eight feet above flood level, closing the bridge and most roads, as well as the water company. That same year, S&K Industries (now owned by Remington Arms), which made a variety of wood products, became the largest employer in Lexington. The first St. Patrick's Day parade was held in 1996, and it became an annual tradition, along with the summer Lexington Community Fair; the fall Apples, Arts, and Antiques Festival; and the Christmas Festival of Lights parade. In 2000, Lexington annexed some surrounding areas, mostly east of town, including the new intersection of US Highway 24 and Missouri Highway 13, which soon crossed the Missouri River on the new Congressman Ike Skelton Bridge. Skelton ended his political career in 2011, having served as chairman of the House Armed Services Committee.

A lot of history has been made in Lexington. Residents are happy to share it with visitors through museums, shops, bed and breakfasts, restaurants, and a lot of friendly conversation.

One

TRAILS AND TRADE

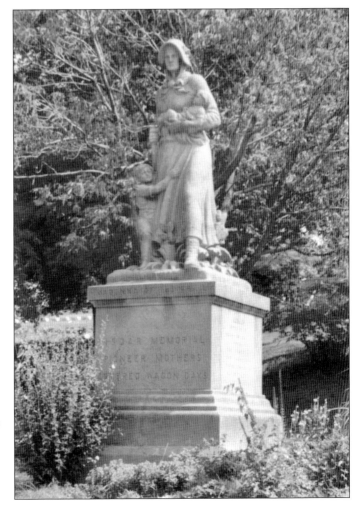

After marking several trails to the west, the Daughters of the American Revolution helped secure the designation of the National Old Trails Road from Maryland to California. It placed a Madonna of the Trail monument, honoring the courage of pioneer women, in each of the 12 states along the route. Lexington's 1928 dedication speech was delivered by Jackson County judge Harry Truman, the national chairman of the project.

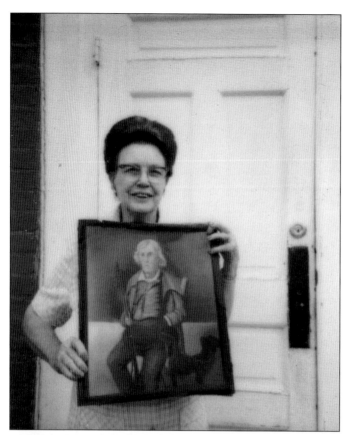

Gilead Rupe built a large log house near the river in 1815. After being burned out by Indians, he built a new house two miles to the south and became a prosperous farmer. At left, a descendant of his, Alameda Griffin of Nacogdoches, Texas, holds an original portrait of Rupe from the Lexington Historical Museum, stamped "H.L. Brown, Portrait Artist." Rupe died in 1847 at age 75 and was buried in Lexington's Machpelah Cemetery, where his original marker is now almost gone. In 1929, the DAR dedicated a new marker, seen below draped with flags. The chairwoman was Boxie Chiles, the wife of Henry Chiles; the pages were Clarence Kenney and Warren Sherman Jr.; and one of the Scouts was William Aull III.

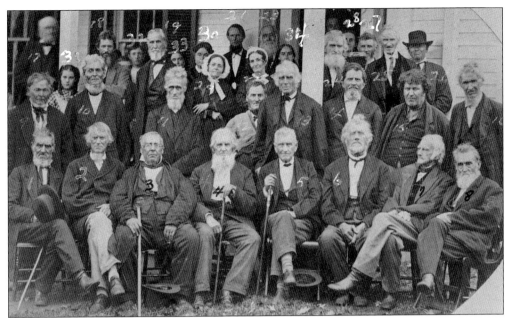

This group (above) is the Old Men's Club, formed in 1868. Any man 70 or older in Lafayette County could join, and members met twice a year to socialize. Each man was required to tell or write his life story, although the original stories have been lost. Some of the most prominent members were James Hicklin (3), "Uncle" George Houx (10), John Catron (15), and Stephen G. Wentworth (18). The location of the photograph is not known, but, obviously, women and children were sometimes included. As an assistant government surveyor, James Hicklin, the nephew of Gilead Rupe, helped his uncle claim his land. Hicklin then became a major landholder just east of town, where he built his home (below), now known as Hicklin Hearthstone, in the 1830s.

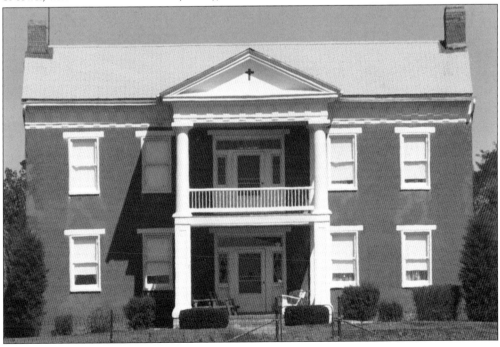

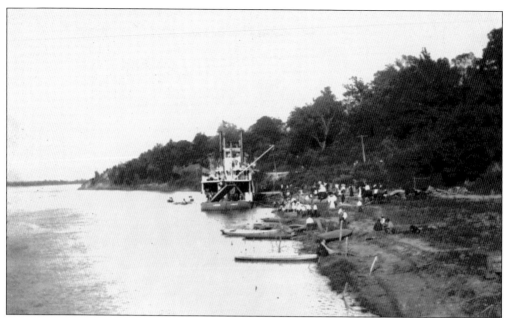

In 1819, William Jack bought the equipment and license for Jack's Ferry. The ferry landing was about two miles from the original town square. Initially, the ferry was just a raft controlled with poles and oars. By the time the photograph above was taken, in the late 1800s, steamboats were used to transport people across the river. Many early houses in Lexington looked like the log house below, which was uncovered in 1982 just above the ferry landing. Although it could have been the home of William Jack at one time, it was later the home of federal marshal Robert Ewing, and then a tavern. The house dates to at least the 1830s, since a large mouse nest was found under the house with bits of newspapers from that time.

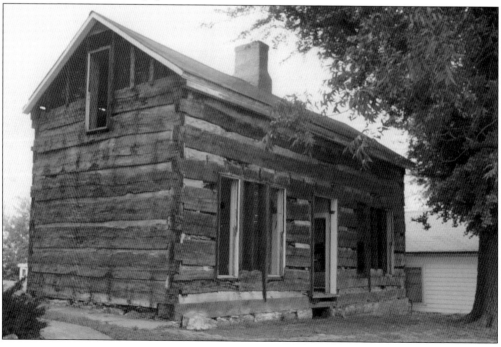

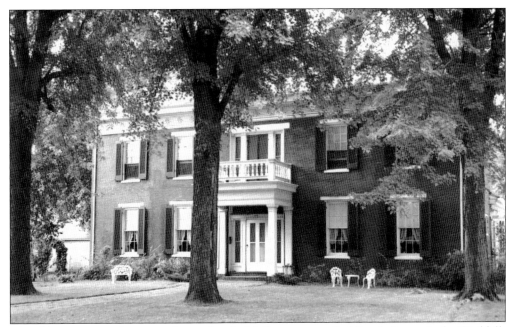

The oldest surviving house on the road to Jack's Ferry, now called South Street, is the Waddell-Pomeroy-Shea-Worthington home (above). Built in the 1830s by John Taylor Waddell as a farmhouse, by the 1840s, this beautiful Federal and Greek Revival–style house was the home of Ebenezer Pomeroy. He married Maria Aull and worked with her brothers, who were prominent merchants. In 1836, Waddell started a family cemetery to the south of his house. After his death in 1839, his son William Bradford Waddell donated the family cemetery and nearby land to form Machpelah Cemetery in 1849. On the south edge of his property, Pomeroy built a brick icehouse. The bridge from Eighteenth Street (below) crossed railroad tracks to enter the cemetery, where the icehouse was being used as a chapel by the late 1800s.

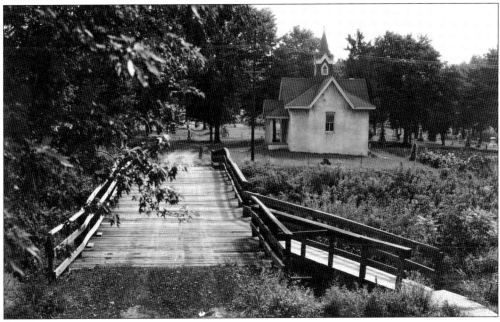

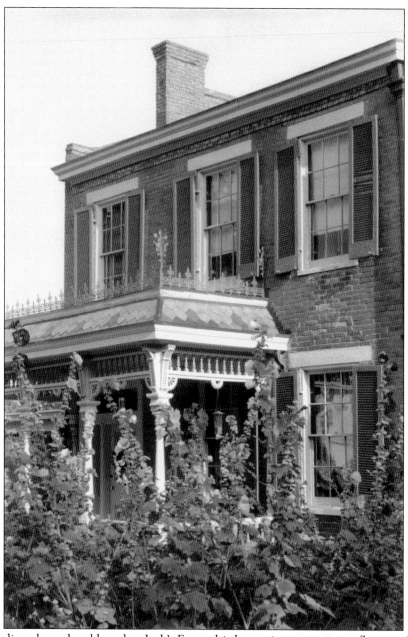

Still standing along the old road to Jack's Ferry, this home, incorporating influences from the Federal, Greek Revival, and Georgian styles, was built by Dr. Richard Buckingham soon after he came to Lexington in 1843. A Union man, he left during the Civil War and became the mayor of Denver, Colorado. Milton Royle came to the area in 1841 and had a mercantile business. The Royles added the Second Empire front porch, the bay window, and the servant quarters in the 1880s. Royle died "at his cozy home" in 1910, according to the county history of that year. The Godfried Spring family arrived in 1910 and soon bought the house, which was then inherited by their daughter Emma, who lived here until the early 1980s and died at the age of 100. In 1983, it was bought by Roger and Sandy Slusher, who restored the home and have opened it for several old home tours. (Courtesy of the author.)

To bring trade from the new Santa Fe Trail through Lexington, the county quickly laid out a road to Tabo Creek, eight miles east. A ferry crossed there near the old county seat, Mount Vernon. Later, a series of covered bridges crossed Tabo Creek; the first was burned in the Civil War, and the last one (above) was washed away by heavy rains in 1927. It was replaced by a temporary bridge until a steel-and-concrete span was built in 1932. To the right is one of the large pink granite markers placed by the DAR to mark the Santa Fe Trail. Lexington's role in the trail was led by the Aull brothers, who were major outfitters on the original square, now called Old Town. The photograph of Old Town in the 1800s (below) shows the oldest fire station, probably built in 1856, which was directly west of the square.

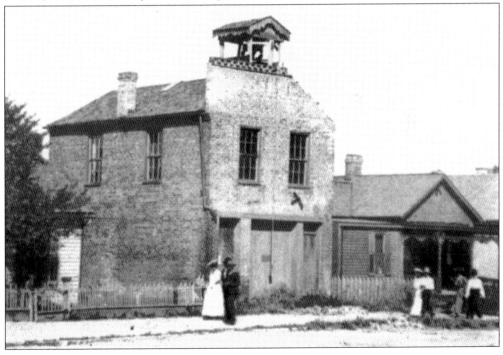

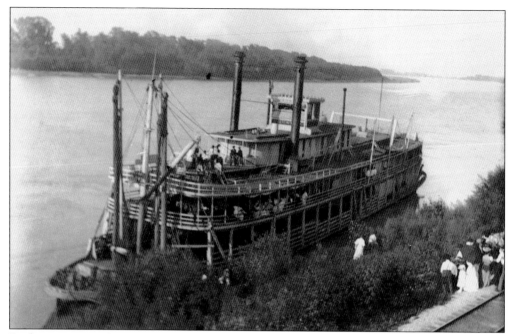

By the 1830s, steamboats were regularly bringing goods and leaving loaded with tobacco and bales of hemp. However, steamboats faced constant danger from submerged trees, fires, and explosions. The worst disaster ever on the Missouri River happened in 1852 when the *Saluda*—similar to the *Chester*, seen here after the Civil War, but with side wheels—exploded as it left the dock.

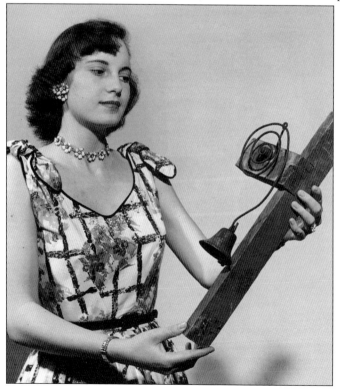

The *Saluda*'s dinner bell, seen here in the 1950s held by Dorothy Hall Kleeshulte, is on display at the Battle of Lexington State Historic Site. Before the explosion, there was ice in the river, so Capt. Francis T. Belt apparently tied down the safety valve, saying he would get up the river or blow it to hell. About 100 crew and passengers, mostly Mormon emigrants, were killed, but the boat was salvaged and later used to build the Gruber house. (Courtesy of the Missouri Department of Natural Resources.)

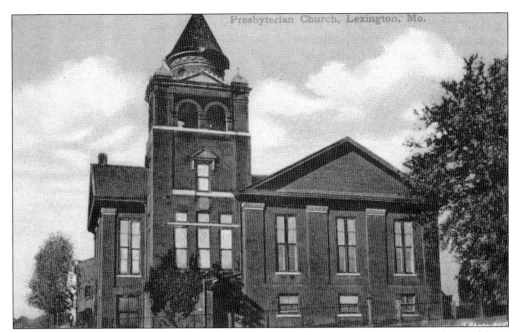

The church now known as Presbyterian Disciples Church was built in 1844 on the donated front yard of James Aull, facing the square where the new courthouse would soon be built. Aull, a merchant and a Santa Fe trader, was killed in Chihuahua, Mexico, in 1847. The bell tower and other additions were made around 1900.

The Christ Church Episcopal was built in 1848 in the Gothic Revival style and features oiled walnut on the interior. Worshipers still use the same pews and kneel at the same altar rail as in 1848. A service for the victims of the *Saluda* steamboat disaster was held here in 1852. The bell tower was added in the late 1800s.

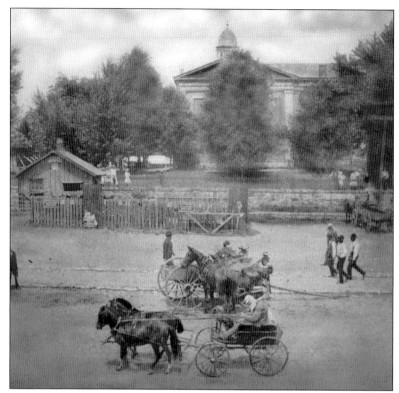

To capitalize on steamboat traffic, the New Town was laid out between Old Town and the river landing in 1836. In 1847, the county court hired local builder William Daugherty to design and build the Greek Revival courthouse, seen here from the south, which is still in use today. In the late 1800s, the area behind the courthouse included a farmers' market and the city scales, seen here to the left.

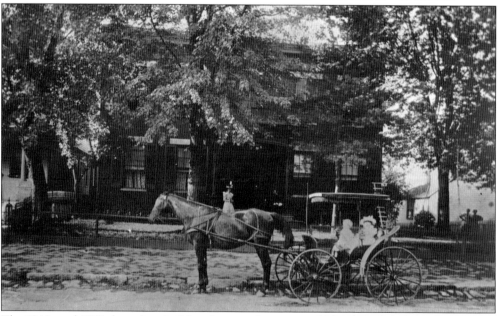

The 1840s and 1850s brought a building boom to Lexington; 33 brick and 29 frame houses were built in 1845 alone. The Farmer-Vialle House, just two blocks east of the courthouse, was demolished in the 1980s. This photograph seems to show a mother heading toward her two children, who are waiting in a nice buggy in front of the house. The cast-iron fence was probably made at the Morrison foundry in Lexington.

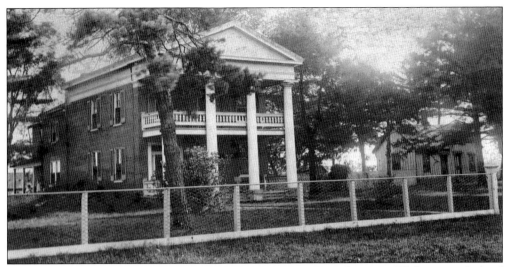

In 1838, John Aull, the eldest of the Aull brothers, went on a tour of Europe. While visiting Ireland to meet his Scots Irish relatives, he decided to bring his young cousin, also named John Aull, back to America. The elder Aull died of malaria in New Orleans on the return trip, so his Irish cousin brought his body back and started to work for the family mercantile firm, which he eventually took over. In the 1850s, he bought the fine, Greek Revival Spratt Mansion (above), which was south of Lexington. One of Aull's friends was William Limrick, another Irish immigrant who had done well in trading and banking. Around 1857, Limrick built the 26-room mansion, called Limrick (now Linwood) Lawn (below), in the new Italianate style on a hill about a mile from the Aull house. It was said that the two friends could wave at each other from their respective upper-story porches.

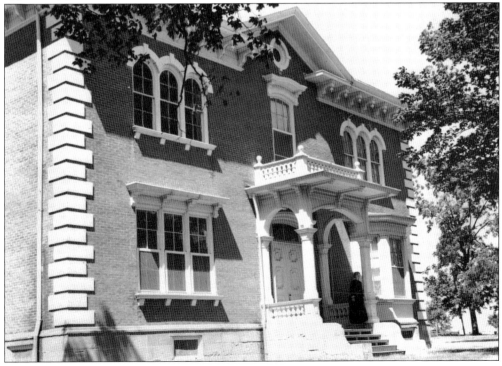

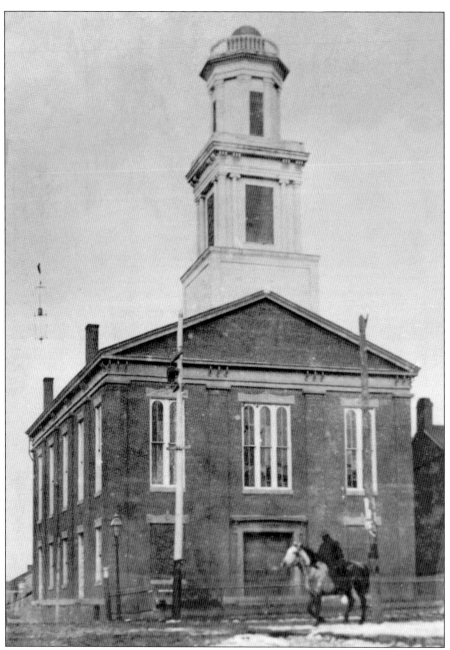

The Federal and Greek Revival Baptist church was begun in 1858—but not completed with the bell tower until after the Civil War, in 1868. The tower and roof were badly damaged by a lightning strike in 1905, so the tower was removed, and a tile roof replaced the wooden shingles. This photograph shows the original church architecture, complete with the large bell tower and cast-iron lintels, both possibly made at the local Morrison foundry, and the parsonage, barely seen on the right. The mysterious dark rider in front of the church is unknown. The photograph must have been taken soon after 1894, when electricity came to Lexington, since two rather large electrical poles are right in front of the church. The congregation vacated the old church in 1972 for a more modern building.

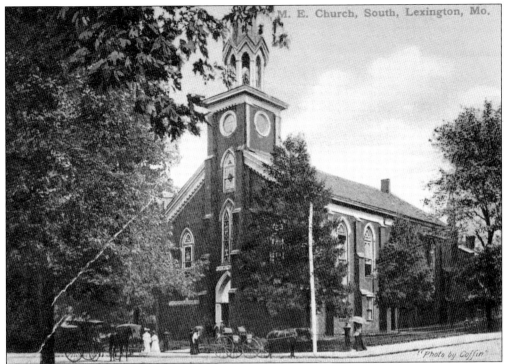

The Methodist church was begun in 1860 in the Gothic Revival style, but it was not actually completed until 1865. This photograph is from before 1915, when complications with the steeple led to a major remodeling. The bell tower was removed and replaced with a freestanding tower, the entrance was moved to the right side, up a flight of stairs, and the entire exterior was stuccoed.

This view was taken from the bell tower of the Methodist church in 1867 or soon thereafter. The 1866–1867 stone county jail is in the center, just to the side of the courthouse. The long buildings in the first and third blocks of Franklin Avenue were a livery stable and a blacksmith shop, respectively. The bell tower was high enough to see the river as it wrapped around town.

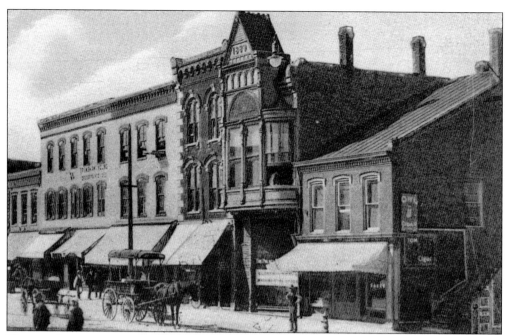

The next large company in town after the Aull family's mercantile empire was Russell, Majors & Waddell. William H. Russell was effective at raising money and working with politicians. Alexander Majors, of Westport, was a master freighter who took many wagon caravans to the West. William Bradford Waddell was a reliable manager of the company's headquarters (above, right), which collapsed in 1926. They joined together in 1857 to win lucrative government contracts to supply all the forts in the West. In 1860, they formed the Pony Express, hoping to get the mail contract to California, but they did not get it, and the company failed in 1861. Waddell gave this house (below) to his son as a wedding present, and it is still in the family today. Note the Pony Express symbol on the porch.

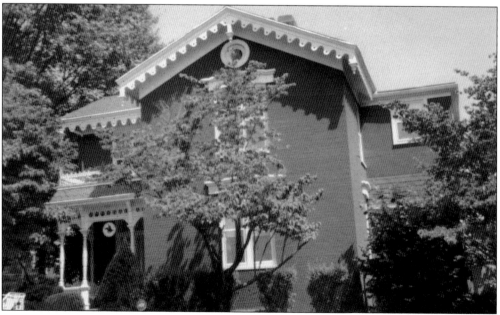

Two

Conflict, Hemp Bales, and Jesse James

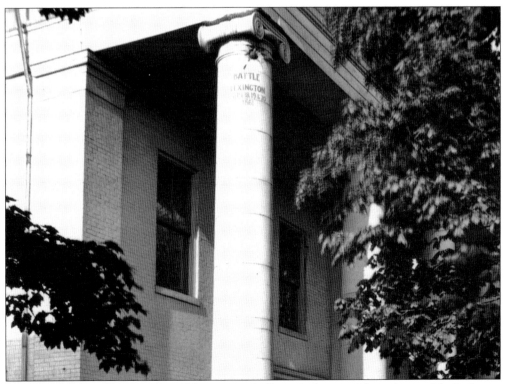

During the Battle of Lexington in 1861, a cannonball struck the top of this column of the Lafayette County Courthouse. A trajectory study has shown that it was probably fired from a Confederate cannon that overshot the Union trenches. The cannonball fell right out, but, around 1920, what was accepted to be the original ball was screwed on a two-foot iron rod that was inserted in a hole drilled in the column, to make sure it stayed there permanently.

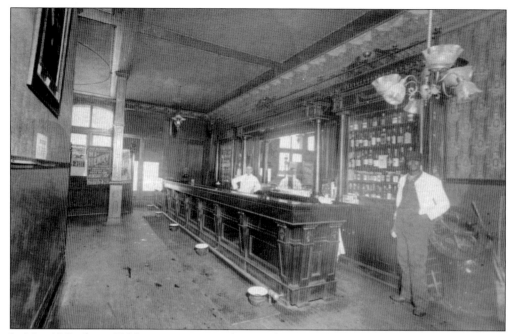

In May 1861, about 20 Union men met at the courthouse and were disrupted by some Southern men who started a fight. Nicholas Haerle saved the American flag from the courthouse, but he was shot in the leg. After being threatened with death if he did not leave town, he went to St. Louis to work for the war relief office. After the war, he returned, saying he held no grudges. He reportedly operated this saloon—and he was buried with the flag.

In July 1861, the first Federal troops, under Col. Charles Stifel, marched up from the landing to see a Confederate flag flying from the porch of William McCausland, as it does here. McCausland's wife, Susan, tried to prevent it from being taken, making her a hero to many. Her husband quickly arrived with a shotgun to protect his wife, but he was arrested for two weeks and the flag was taken.

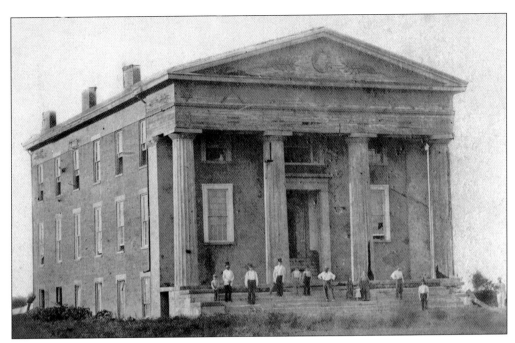

The Masonic College for young men, particularly the orphaned sons of Masons, opened in 1847 and closed in 1857. The building was chosen by the Union forces occupying the town for their headquarters. Considerable unrepaired battle damage is seen (above) in this photograph taken soon after the battle. Union forces took almost $1 million of the state education fund from the Farmers Bank (below, right) for safekeeping. Col. James Mulligan slept in a tent to the right of the Masonic building with the money buried under him. When victorious general Sterling Price returned the money after the battle, Gov. Claiborne Jackson kept about $37,000 of it for state defense, and about $10,000 was somehow lost.

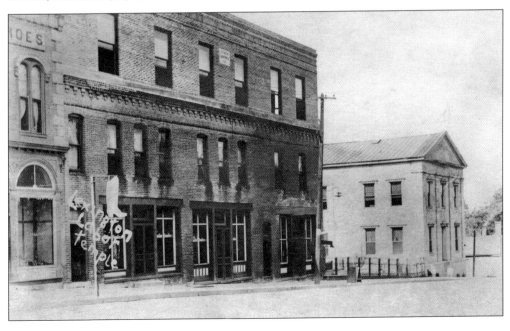

About 3,000 Federal forces, under Col. James Mulligan of Chicago's Irish Brigade, dug trenches around most of the high ground (above) on the old Masonic College campus. Several of the trenches are visible to the left of the water tower. About 20,000 Missouri State Guard troops and local volunteers under Gen. Sterling Price completely encircled them. The Federals said the former home of Col. Oliver Anderson (below) was their hospital, but it was not within their trenches. General Price said there was firing from the house, so it was captured on September 18, 1861. Union volunteers quickly recaptured it, only to lose it an hour later. There was steady firing the next day, but the Federals were running out of water, so, using moving breastworks of hemp bales, the pro-Confederate forces prevailed on the third day. (Both, courtesy of the Missouri Department of Natural Resources.)

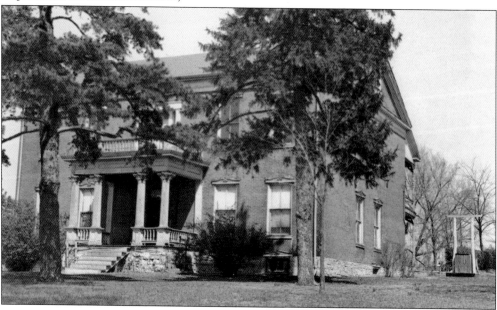

When Colonel Mulligan surrendered his sword, held at right by John Wallace and a young lady in the 1950s, General Price returned the sword, graciously saying that he had never faced such a determined enemy. The sword was later stolen by a local man, who managed to hide it until about 1900. At his wife's urging, he returned the sword to Colonel Mulligan's widow. She and her one-year-old daughter had stayed with the pro-Confederate John Aull family during the battle, and the daughter later returned it to Lexington as a thank-you for their kind treatment. Below, during one of the periods of Union occupation, in 1862, the Ladies Union Aid Society presented an American flag to Company E of the First Missouri Light Artillery in front of the county clerk's office, left of the courthouse. (Right, courtesy of the Missouri Department of Natural Resources.)

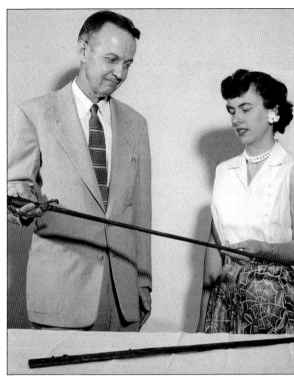

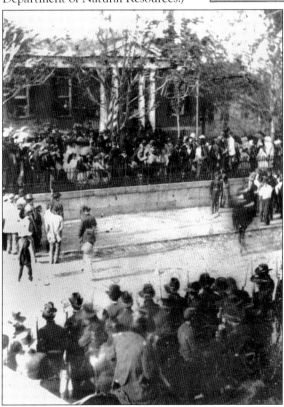

The stone building to the right, on the old landing, was a Union prison. Captured bushwhackers and persons suspected of disloyalty may have been held there before being tried or sent east. In 1864, a guerrilla leader conspired with a woman and a guard to free a bushwhacker named Otho Hinton, possibly from this building, but the guard revealed their plan, and Hinton and another man were killed.

Familiar with this area after bushwhacking during the war, the James Gang robbed the Alexander Mitchell Bank (seen here) in 1866, taking about $2,000 and a little gold watch, which was returned when they discovered it belonged to a little girl. They returned in 1874 to rob the omnibus that ran between the railroad depot and the ferry landing on the north side of the river, but only got a little money and a few personal items.

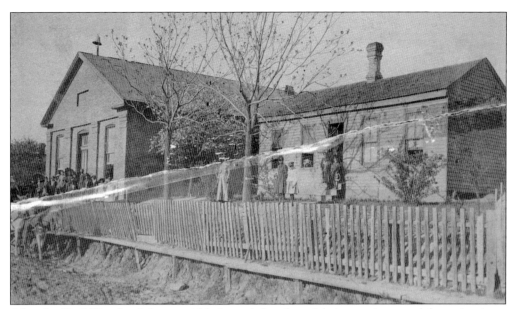

After the Civil War, freed slaves quickly formed churches of their own, in several denominations. The St. John Methodist Church (above) was built in 1868 on North Twelfth Street. At the time of its founding, it had 147 members, 75 of them adults. The building no longer stands. The Zion African Methodist Episcopal Church (below) was built in 1870 and is still standing, although it is vacant. The steeple was removed around 1900. In 1880, it had 137 adult members, making it the largest African American congregation in the county.

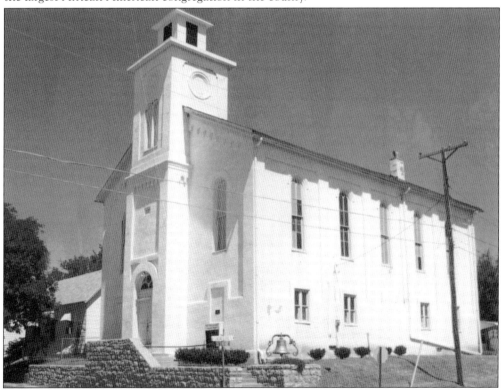

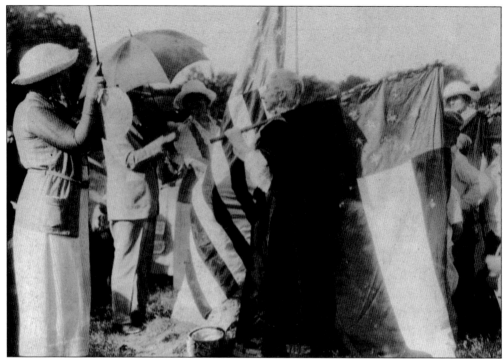

Susan McCausland (center) is seen here dedicating a United Daughters of the Confederacy monument in Machpelah Cemetery around 1900. She wrote, "When unfurling the Confederate flag I dropped my hat [seen on the ground in front of her] . . . In recognition of my meaning, many men in the crowd also took off their hats, but held them in hand . . . I went them 'one better' in unreconstructed loyalty to the Confederacy."

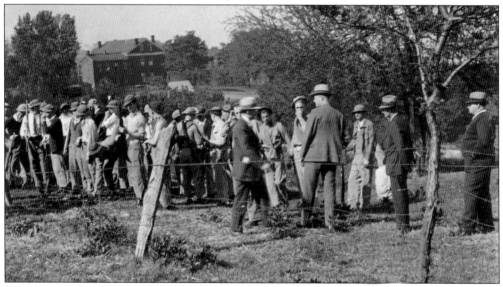

Whether in remembrance of the Confederacy, for historical purposes, or just for fun, the "Battle of the Hemp Bales" has been reenacted many times. This photograph shows an early attempt, probably in the 1920s, with young men who seem to be just as confused as the soldiers were during the original battle. The Anderson House looms in the background.

Three
RAILROADS AND COAL MINES

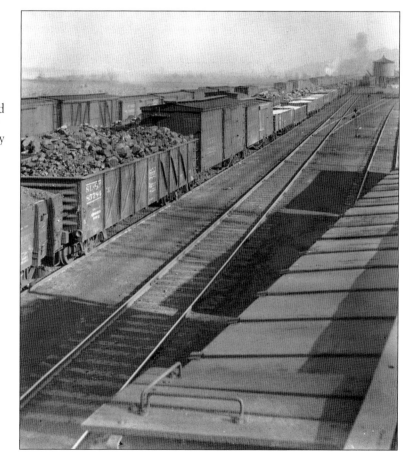

As railroads moved into the area after the Civil War, they burned coal and sometimes owned the mines. They also transported coal out of the area, as seen in this early-1900s photograph taken near the Myrick station. Coal was used locally to heat homes and businesses as well as to produce gas and electricity. Demand lessened with competition from hard coal and diesel trains, and the last mine closed in 1965.

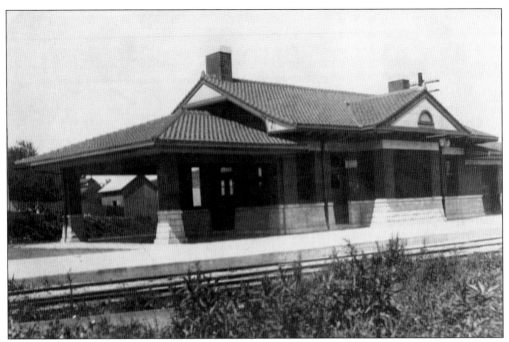

The first railroad completed to Lexington was a spur off the main line from Sedalia in 1871. This Spanish-style building, located off Twentieth Street northeast of Machpelah Cemetery, was the Union Pacific's main passenger station for many years. It was demolished in 1987. Its track has been abandoned, and, in Lexington, the former right-of-way is now a walking path from the east edge of town to the bottom of the bluff.

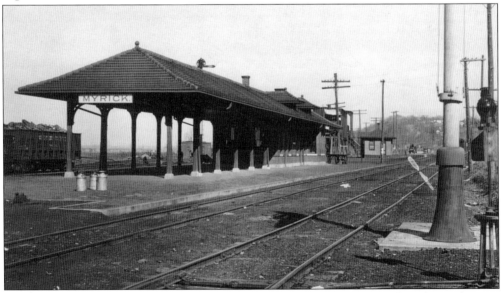

In 1876, a narrow gauge railroad was run from Kansas City to Lexington, but the tracks were soon sold to the city for a trolley line after the Missouri Pacific (now Union Pacific) was built along the river from Kansas City through Lexington to Jefferson City and beyond in 1881. Its station, seen here in the 1920s, was west of Lexington, in Myrick. Mainly a busy freight station, it was demolished by the 1970s.

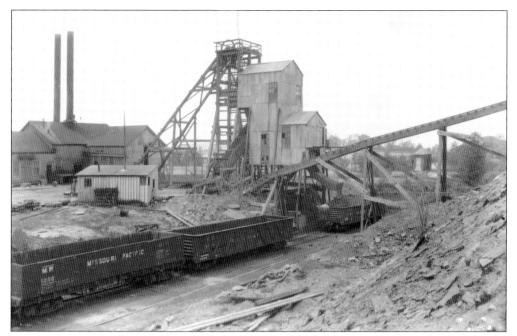

Most of the early coal mines were drift mines that ran horizontally into the coal vein from the river bluffs. But, in the 1880s, the Western Coal & Mining Company, whose West Mine is seen here, and others such as the McGrew Coal Company began to use deep shaft mining. As seen here, they used coal-fired power plants to work the elevators that raised the coal, and then sent it by conveyor belts to the waiting railroad cars.

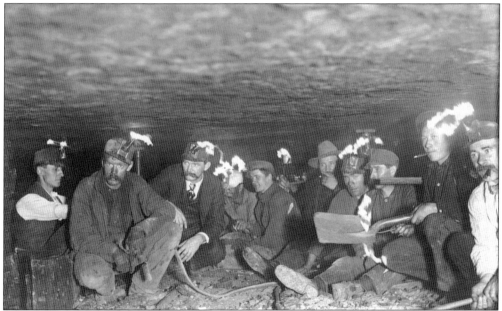

Many miners started work at age 14, when they were hired as wheelers to push full cars on tracks to where they could be hitched to mules. Miners mainly worked on their sides or on their knees using knee pads, with carbide lamps for light. This must have been a special occasion, since some of the miners seem overdressed for work.

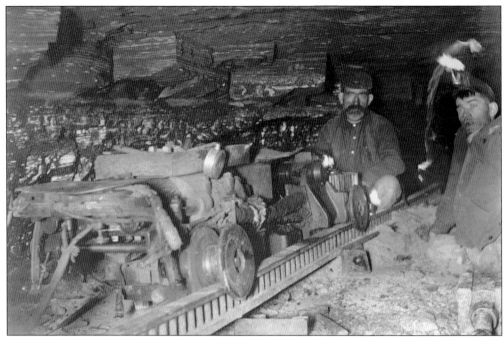

By the early 1900s, complicated machines like this one drilled out the coal, replacing pickaxes and shovels. They sped up the production of coal and were usually easier on the men, but the noise level increased. The seam of coal was only about 18 to 24 inches, so the mines expanded constantly.

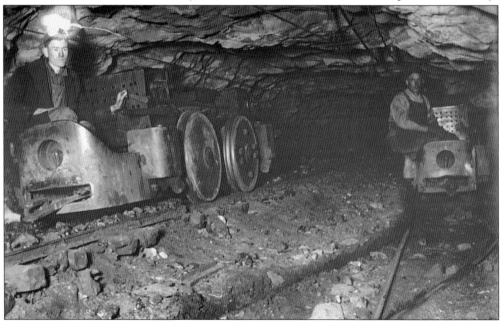

These men are drivers of the small engines that pulled or pushed loaded cars of coal out of the mines, to elevator cages or to the surface, depending on the type of mine. This mechanization led to fewer jobs being available for the really young men, so more of them attended the public high school, which was available by 1871 and was quite fashionable by 1891, when the large new high school opened.

More than 2,000 freedmen and immigrants, especially from Ireland and Italy, came to work for about 46 different mining companies by 1900. The semiweekly payroll at the time reached about $750,000. Most of the miners lived in shacks owned by the companies near the mines, but some of them, like the large O'Malley family, who lived in this brick house on Irish Town Hill in southwestern Lexington, had a fairly comfortable, if crowded, life.

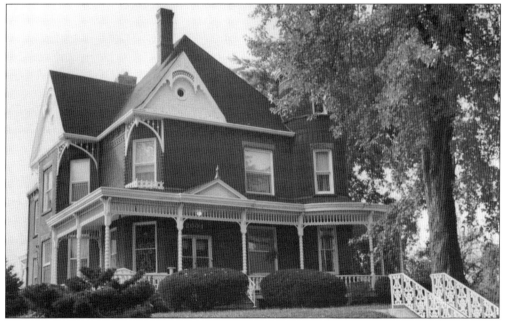

Mine owners often made great profits and could afford much nicer homes. This beautiful Queen Anne home with many stained-glass windows was built by Ed McGrew in 1890. With his father, James McGrew Sr., and his brother James McGrew Jr., he owned several shaft mines west of town. The tower on the right still has a flagpole that can be raised from the inside, and there is a ballroom on the top floor.

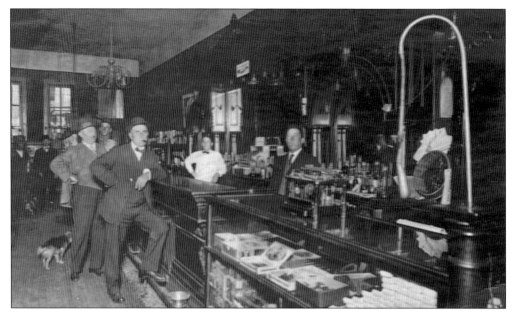

When they were paid, many thirsty miners headed for the notorious Block 42, just west of the courthouse on Main Street. Legend has it that there were 42 saloons, including Palmer's Saloon, owned by William Palmer Sr., seen here. While there was not room for that many bars, if the prostitution and gambling on the upper floors were counted, there were probably 42 choices of diversion.

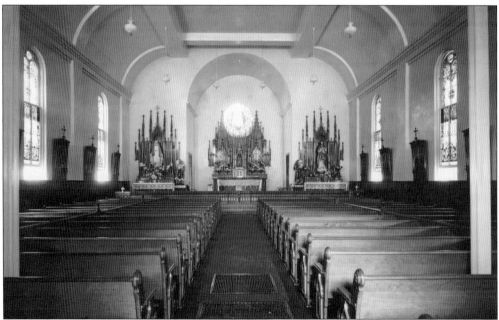

On Sundays, another form of social activity was very popular with the mining families, as the Catholic church quickly became the largest congregation in town, and remains so today. After the church on Highland Avenue collapsed in 1880, parishioners built the magnificent Immaculate Conception Catholic Church at Eighteenth and Main Streets in 1898. This photograph shows the original interior in the 1930s.

Many miners joined the United Mine Workers and other union groups, although no major strikes occurred. Miners also gathered for social events and meetings at the Lexington Labor Temple, seen here, upstairs on the south side of the 800 block of Main Street. The building later became the meeting area for the German Turners organization.

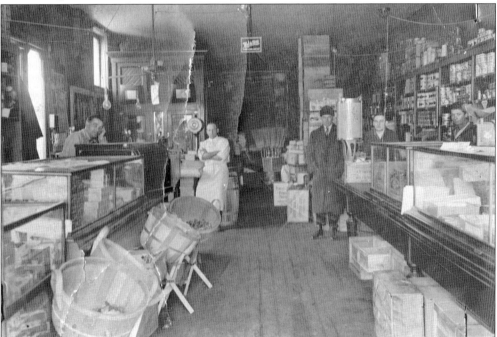

Various ethnic groups often banded together for support and socializing. The French-Italian Cooperative Store was located at Eleventh Street and Franklin Avenue, in the oldest commercial building still standing in its original condition. Seen here from left to right around 1900 are Louis Minor, Bill LeJeune, Pete LeNoch, Dutch Mischon, and Pete Collobert.

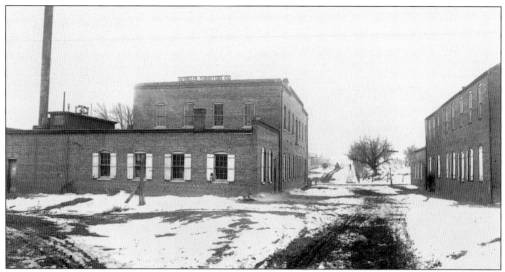

Henry Winkler arrived in 1856, and his brother Frederick soon joined him in a small furniture-making shop. By 1870, the Winkler Furniture Company, seen here on South Street in 1904, employed up to 55 men and was the largest furniture manufacturer west of St. Louis. It also built caskets and opened the Winkler Funeral Home in the building to the right. This photograph was taken by Albert Walter Sandring and is owned by his grandson. (Courtesy of Albert Winkler Sandring.)

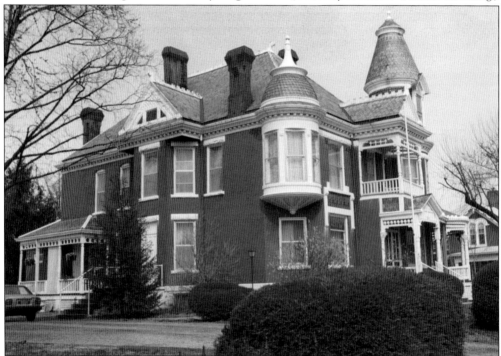

In 1888, the Winkler Furniture Company opened a retail store at Tenth Street and Franklin Avenue, and it specialized in woodwork for churches and homes, such as the 1885 Robert Taubman home, seen here, now known as Victorianne. Taubman was in the milling business, served in the Union army, was elected sheriff, and was president of the Commercial Bank. The Winkler Furniture Company closed in the 1930s, but the retail store continued until the 1970s.

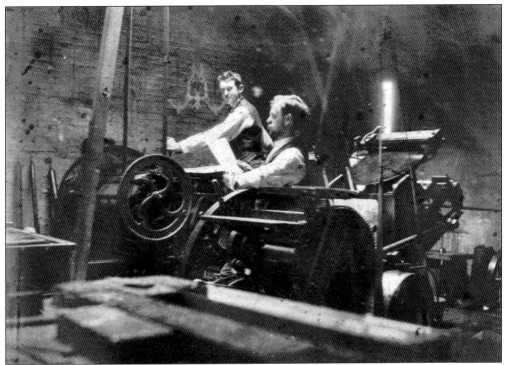

This photograph shows a newspaper and printing shop around 1900. In the 1870s, there was a Democratic paper, the *Intelligencer*, which lasted until 1910, and a Republican paper, the *Register*, which lasted until 1890. By 1910, the *Advertiser* and the *News*, which later combined into the *Advertiser-News*, had both been founded. The *Advertiser-News* survives today as the *Lexington News*.

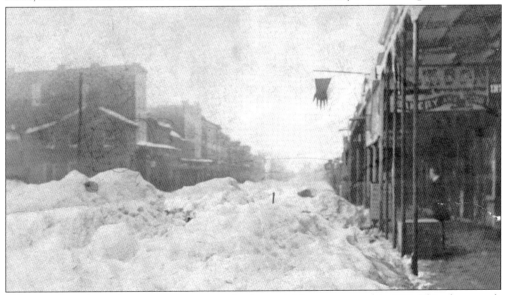

What may have been the worst snowstorm in Lexington's history occurred in 1878. This photograph shows Main Street piled with snow after it was shoveled off the sidewalks. The photographer seems to be looking east from Ninth Street, with Block 42 on the right. Note the man standing on the right staring at the mess.

This building, now the Second Baptist Church, was originally a relatively simple structure built by the First Christian Church in 1840. The Baptists bought it in 1873, and almost completely rebuilt it in the Romanesque Revival style in 1893. It is the only African American church still active in Lexington.

The new First Christian Church was built in the Romanesque Revival style in 1870, when the style was rather new. The steeple was removed around 1900 because of the fear of lightning strikes and maintenance costs. Recently, the church has become a private home, and the congregation has joined with the Presbyterians in the Presbyterian Disciples Church.

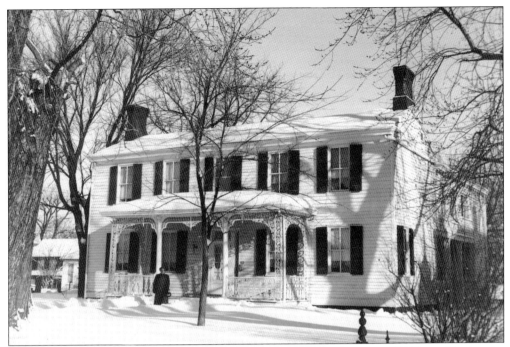

In 1855, the Baptist Female College opened in the former courthouse in Old Town. During the Civil War, the courthouse was occupied by Union troops and then made a pesthouse for malaria victims. Because of this, for a few years during the war, classes were held in this 1830s house, the home of Rev. Elijah Dulin, the president of the college. It was later the home of Emory and Katherine Todhunter. Katherine is seen here in front of the house.

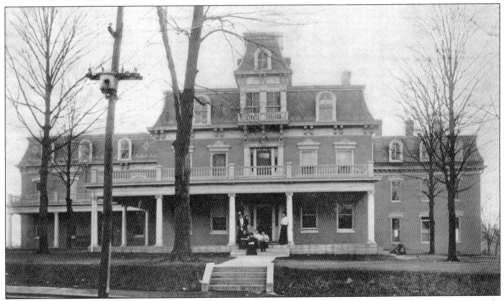

In 1868, the former home of William Bradford Waddell was purchased by the Baptist Female College. His Greek Revival house was eventually turned into a Second Empire masterpiece, with wings added on both sides. Pres. Harry Truman's mother was a graduate of the Baptist Female College. By 1912, the name was changed to Lexington College for Women.

Baptist Female College students (above) enjoy the grounds east of the main building. Note their matching hats, and the boy looking over the fence at the photographer. He is standing in front of the pre–Civil War house (below) that became the music conservatory around 1900. Despite many attempts to save the school, it closed in 1916. The next owner of the house, a Dr. Butler, added the large porch in 1918.

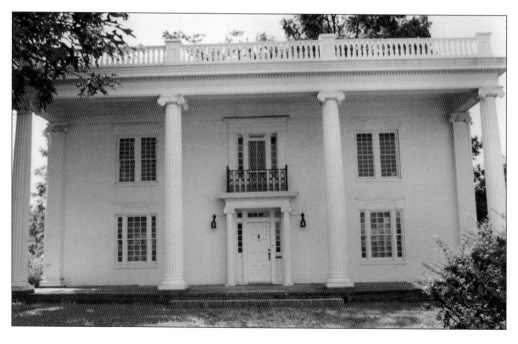

The Elizabeth Aull Seminary, seen above in the late 1800s, opened in 1859 as a Presbyterian female school with high school and college departments. In her will, Elizabeth Aull, the unmarried sister of the Aull brothers, left the H.S. Chadwick house, which she had received as payment for a debt of Chadwick's, and $10,000 to the Presbyterian Church. The only proviso was that the church had to raise another $10,000 to receive the bequest for a school. It could only raise $6,000, so Robert Aull gave the church his house (above) and $5,000 so it could start the school. The wings to the left were added later. The school prospered and was not only able to expand the house, but also bought the whole block, including the Chadwick house (below), which became the school president's home.

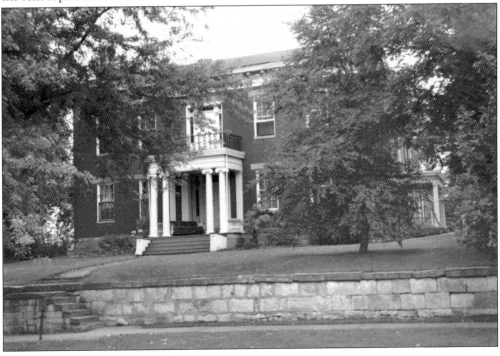

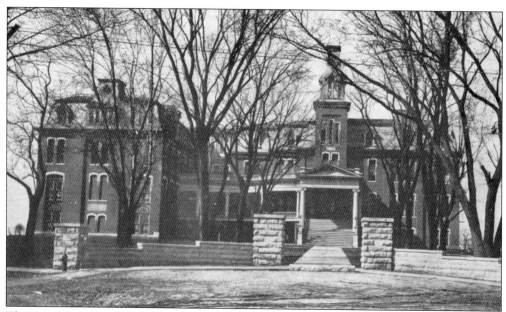

The Central College for Women was opened by the Methodist Church in the old Masonic College building in 1869. The original structure was eventually swallowed up by a massive Second Empire building, seen above around 1915. The photograph below shows two Central College students. Interestingly, there is a Wentworth Military Academy pillow between them. It has been said that when cadets came to serenade the female students with the "Wentworth Song," the girls would throw strawberry jam at them. In 1925, the college was combined with Central Methodist College in Fayette, Missouri, and the vacant building burned in 1932.

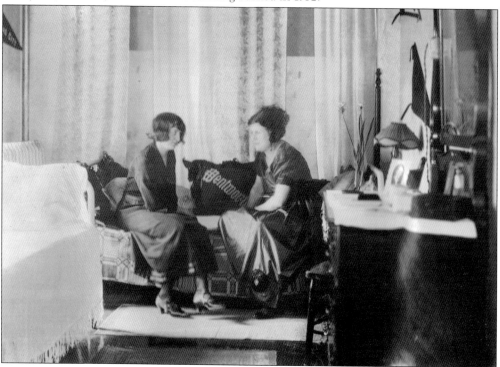

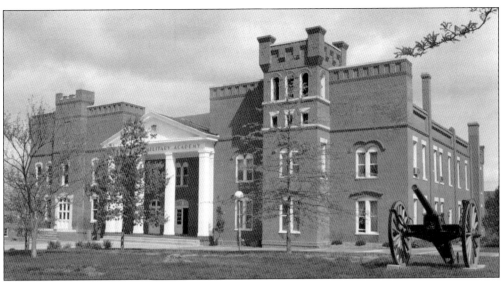

Wentworth Military Academy was founded in 1880 by Stephen G. Wentworth, a merchant and banker, in memory of his son William, who died at age 27. The school began in an old Presbyterian church at Eighteenth and Main Streets, but quickly moved into a pre–Civil War house one block to the north. That house is essentially still preserved, in the center of the school's administration building seen above. The first superintendant was Col. Sanford Sellers, seen below on the far left of what appears to be the officer corps around 1900. Part of the original house is behind the men. Wentworth has been a part of the government military program since 1896, and a junior college was added in 1923.

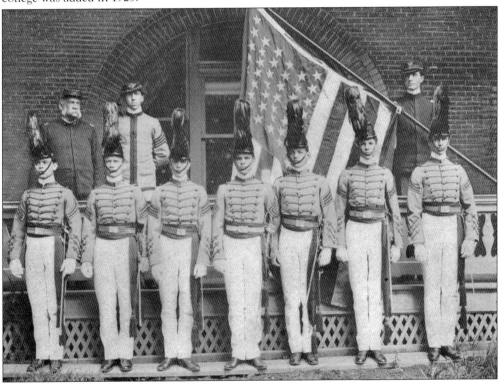

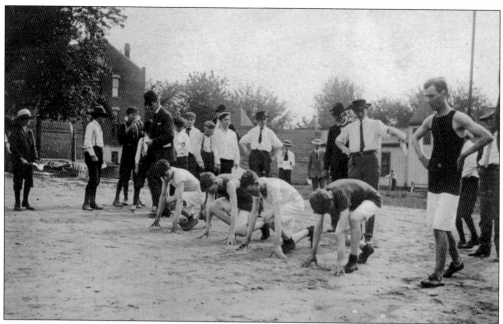

This Wentworth Military Academy track meet was held around 1900 behind Hickman Hall, the first barracks built on the campus. To the right is the old drill hall with pointed corners, near where the football field was later built. The cadet standing on the far right is thought to be Alvin Slusher. (Courtesy of the author.)

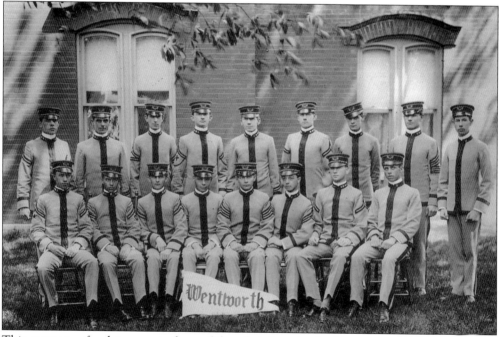

This company of cadets poses in front of the administration building around 1900. In the past, Wentworth attempted to copy the uniforms of West Point, but recently it has tended to follow the lead of the Army. It is the only private school remaining in Lexington, and it still includes high school and college departments.

Four

VICTORIAN TIMES

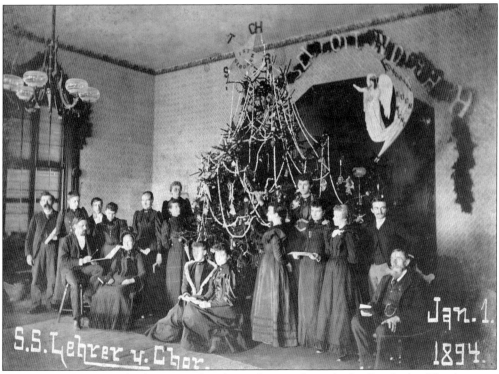

The choir of the Evangelical Trinity Church, in what was formerly the Cumberland Presbyterian Church and is now the Lexington Historical Museum, poses on New Year's Day in 1894. The choir director, S.S. Lehrer, is seated to the left, holding his baton. The unidentified minister is holding a Bible and seated to the right. The group is celebrating Christmas with a large Christmas tree in the German tradition.

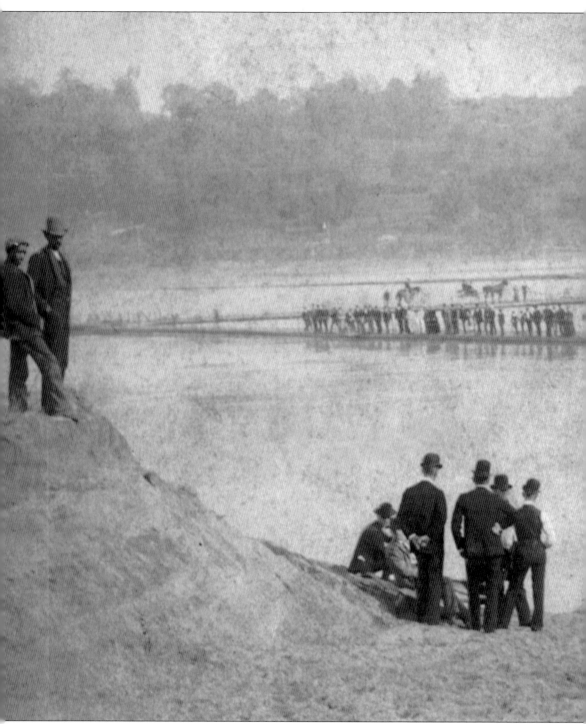

A pontoon bridge owned by a private company opened across the Missouri River in September 1889. It was open 24 hours a day and only cost 50¢, compared to the ferry, which required a roughly 20-minute wait, was slower, had a limited schedule, and charged more. The bridge's angular

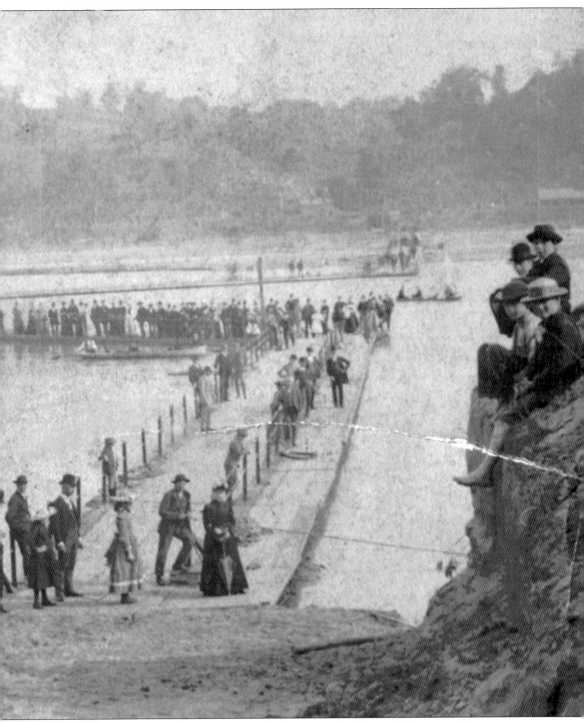
shape made it stronger and easier to open for boats on the river, which were quite common at the time.

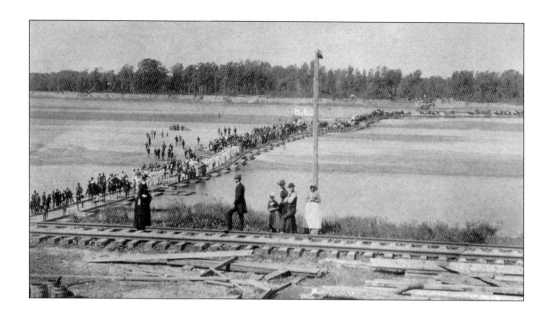

After a parade (above) for the opening of the pontoon bridge, there was a performance by Lexingtonian Charles Geyer, pictured in his snake costume (below), who was a circus contortionist. Music was provided by the Turners' Band, standing behind Geyer. The three men on horseback are, from left to right, J.R. Moorehead Sr., the owner of a lumber company; Ernest Hoffman Sr., the owner of the brewery and ice plant; and J.W. Homer. The ferry company did not appreciate the competition from the 1889 bridge, and a war of words and prices broke out. Despite high hopes, the bridge was removed after about a year, due to ice jams, high water, and cattle stampedes. Ferry boats continued to be used until a steel bridge was opened in 1925.

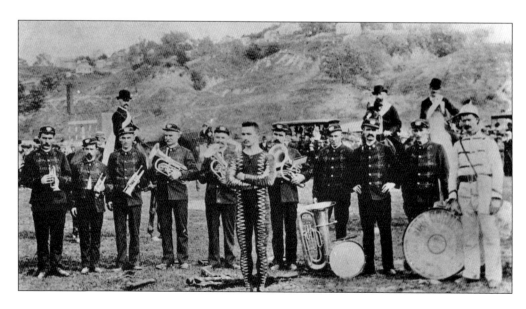

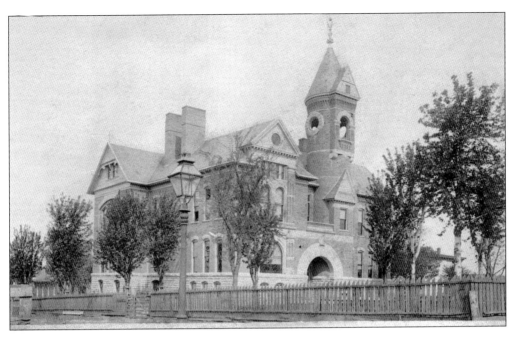

Lexington High School, built in the grand Romanesque Revival style, opened at Thirteenth and South Streets in 1891. Public high school classes had been available since 1871, but they were taught in the Second Ward School with all the other grades. At that time, Herman Demand was the first superintendent of schools, and he is credited with enlarging the library, establishing a science laboratory, and raising requirements so students could gain admission to the University of Missouri. A typical class at the school is seen below. A new high school opened in 1927, and this building housed a grade school called the Central School until 1957. The building burned in 1964, and a post office was constructed on the lot in 1965.

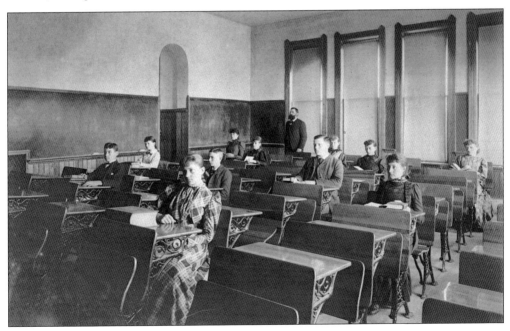

In 1854, Lexington's first public school, known as the Public School House, was built on Southwest Boulevard. In 1868, it became the Second Ward School, which included the public high school until 1891. In 1894, the original building was demolished and the Taylor School, seen here, was built in its place. It was vacated in 1921 and later demolished.

The Third Ward School (later the Arnold School) was built in 1902 and expanded in 1910. It served as a grade school until 1957, when the new Leslie Bell Elementary School was opened. When the older school was sold, the porches were removed and the whole exterior was stuccoed, and it is now an apartment building.

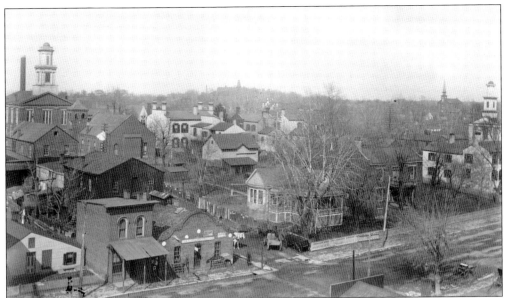

This photograph was taken from the roof of the Hoffman Brewery on Franklin Avenue in the late 1800s. To the upper left is the Baptist church, and across the street is the Second Baptist Church. In the center distance is the Second Empire tower of Central College, and to the upper right is the Zion African Methodist Episcopal Church steeple and the Evangelical Trinity Church bell tower. Note the horses and delivery wagons in the center foreground.

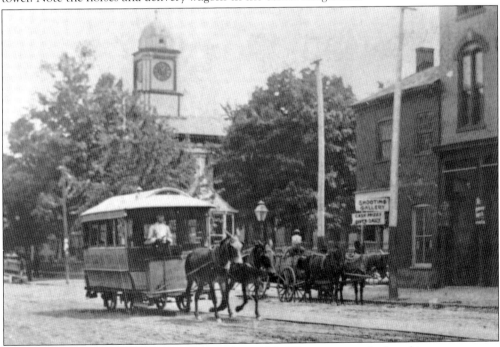

This streetcar is being pulled by mules in the late 1800s. The city granted a franchise to a company that bought the narrow gauge rails that had run from Lexington to Kansas City. The trolleys went down all the main streets, and a person could go from the Elizabeth Aull Seminary, overlooking the river, to a saloon known as The Fort, in Old Town, about two miles to the east, for 10¢.

Horses and mules had many uses in the late 1800s. Above, a man, who may be a member of the Bour family, prepares to make a delivery from the Bour neighborhood store, at Eighteenth Street and Franklin Avenue. Judging from the condition of the wheels, the carriage may have recently gone through some snow or mud. Below, there is definitely snow on the ground, and a resident appears to be moving out after a fire. Note the man with the hose on the left and the young onlookers in the foreground. The men on the stairs are bringing down a piano.

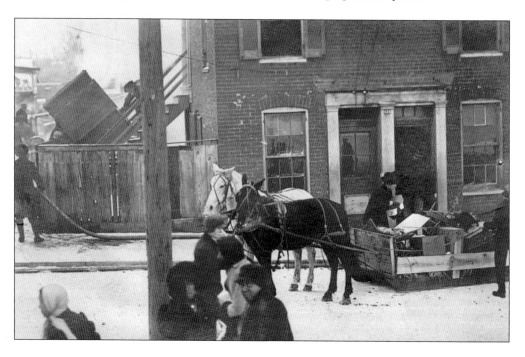

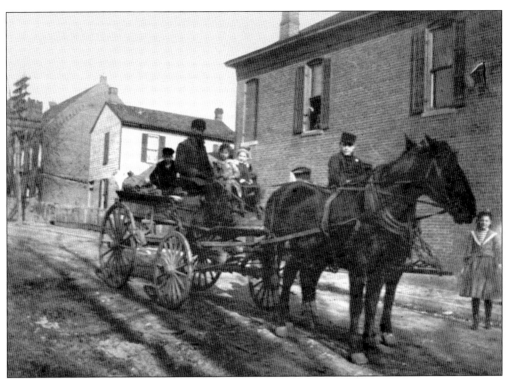

This family poses with a wagon full of goods on South Street between Eleventh and Twelfth Streets in the late 1800s. The large brick building at the top of the hill is the German Methodist Episcopal Church, which was built in 1879 and still stands today.

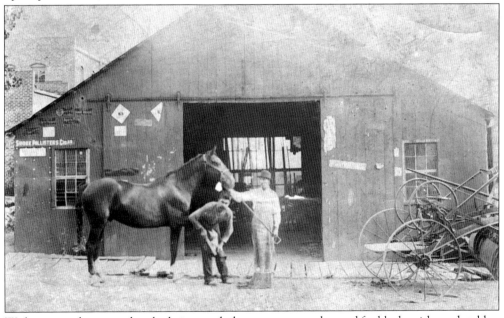

With so many horses and mules being used, there was a great demand for blacksmiths and stables. Here, a blacksmith and his assistant file the hoof of a magnificent horse in front of their shop. The men and the location are not identified.

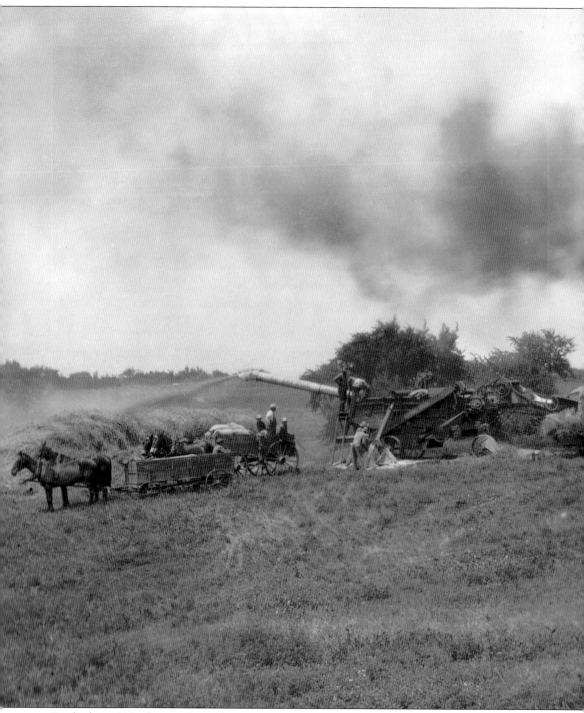

By the late 1800s, farmers focused on row crops such as wheat. Threshing—separating the seeds from the wheat straw and husks— was a major economic and social event. Seen here, from right to left, the steam engine powers the conveyor belts and the threshing machine as the wheat is

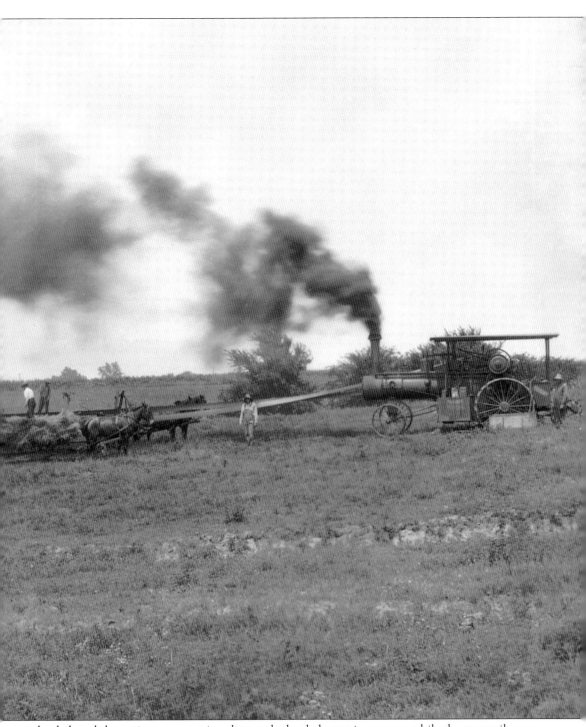

loaded, and the grain comes out into bags to be hauled away in wagons, while the straw piles up to be used as bedding for animals in the winter.

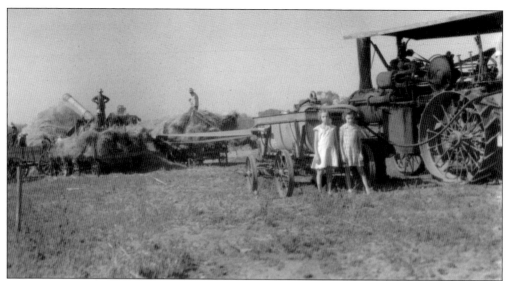

Everyone got involved in threshing. Often, several neighbors brought their crops to one location. The women served meals and took care of the children, who enjoyed being part of the big event.

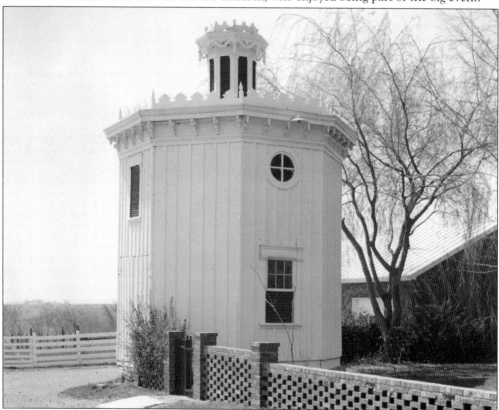

In the late 1800s, many older houses were modernized with new stylistic touches such as Italianate bay windows or Second Empire porches. This beautiful Carpenter Gothic, or wedding cake, icehouse was added during that period at the Spratt-Aull house, just south of town. There was a room above the ice pit where men were reportedly sent to "cool off" if they came home drunk.

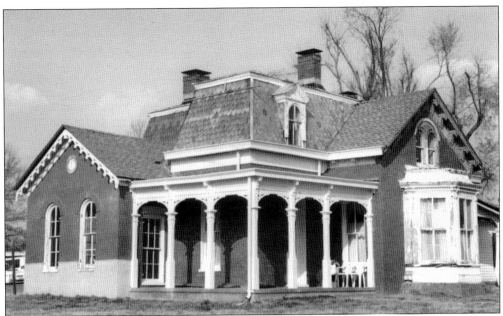

The Italianate style was popular after the Civil War, but in the ensuing years, a variety of architectural styles appeared. The best examples of the Second Empire style, with its sloping mansard roofs that often leaked, were the Baptist and Methodist colleges, but they are both gone. The only fairly pure Second Empire building remaining in Lexington is the Dr. E.T. Schaberg house, just south of the Lafayette Regional Health Center.

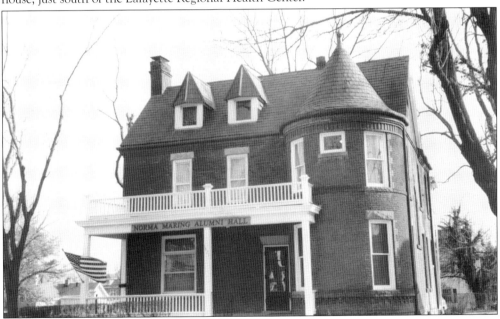

Another architectural style seen in the area was Romanesque Revival, with its towers, Roman arches, and medieval feel. The best example was the 1891 high school, which burned down, but it can also be seen in the 1870 Christian church; the Hook house, at Nineteenth and Main Streets; and, in more elaborate form, the Tabb House, now the Norma Maring Alumni Hall on the Wentworth Military Academy campus. Note the large tower to the right and the slate roof.

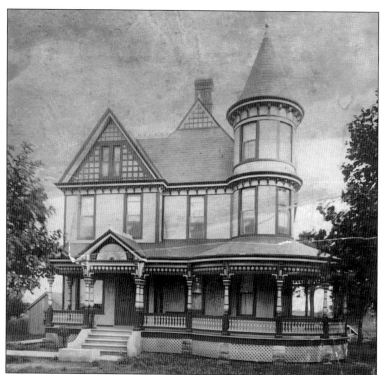

The most popular house style in the late 1800s was Queen Anne, with its towers, decorative wraparound porches, and multicolored paint patterns. This house was built in 1887 by T.T. Stramcke, a prosperous farmer and businessman, about a mile south of Lexington. It was the most elaborate Queen Anne in the rural area, with a very striking color pattern.

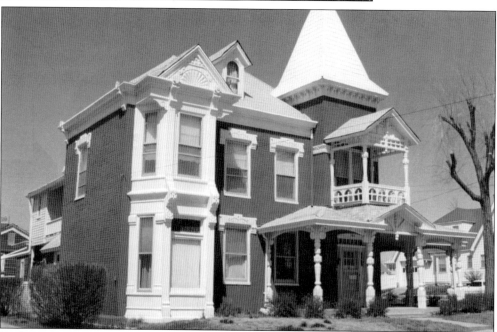

With a rather unique tower and balcony, this house, known as Moorehead, was drastically remodeled from its Greek Revival form by J.R. Moorehead around 1890. He owned a large lumberyard, and the 1912 *Pictorial Souvenir of Lexington* calls him "our foremost citizen" for his business and charity work. The roof of the tower is tin, but the moldings around the bay window are stainless steel, a feature that has helped its preservation.

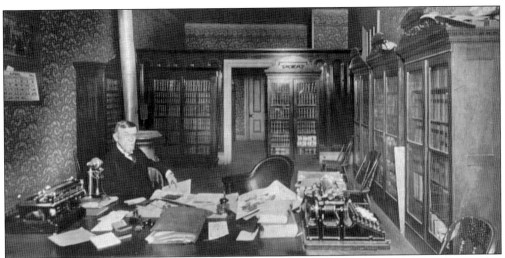

A prominent lawyer in the late 1800s and early 1900s, William H. Chiles is seen here in his law office. Note the early typewriter to the right and the telephone on his slightly messy desk. Telephones were introduced to Lexington in 1871. For the national 1876 centennial, Chiles wrote a short history of Lafayette County. The 1910 *Young's History of Lafayette County, Missouri* notes that he was known for his "amiability" and "spriteliness."

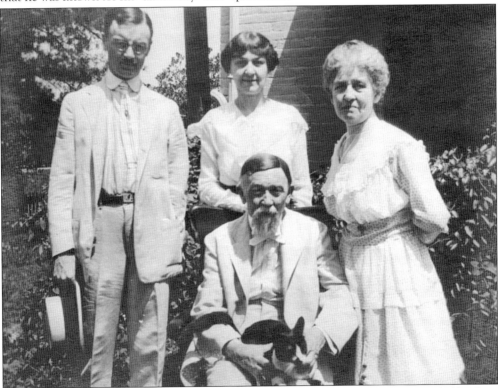

In this family portrait, William H. Chiles is seated, holding his pet cat. He is surrounded by, from left to right, his son Henry C. Chiles, a lawyer who also became a local historian; Henry's wife, Boxie; and William's wife, Mary. In his later years, William lived with Henry in a pre–Civil War house at Eighth and South Streets, which is now gone.

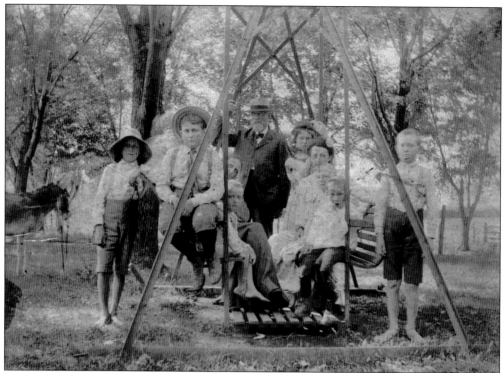

Family outings became more possible as the middle class began to expand. Here, family members poses around a rather elaborate swing set with a local celebrity, state representative Joe Christy. Clark Johnson is listed as second from the left, but no one else is identified. Along with the seven children, there appears to be one woman on each side of the swing, and a horse on the left.

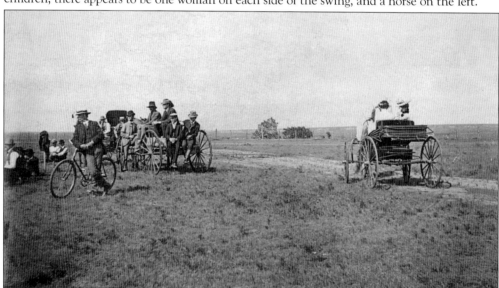

Whoever took this photograph seems to have been more interested in the spectators than in whatever they were watching rather intently. Although there are a wagon and two buggies, the group could not have been too far from town, since one man is leaning on his bicycle, and they are all rather well dressed, as people tended to do in those days. (Courtesy of the author.)

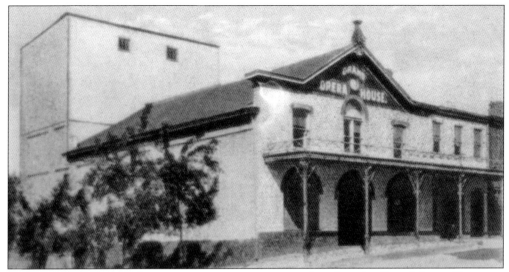

Probably the highest-quality entertainment in town was found at the Grand Opera House, at Ninth Street and Franklin Avenue. Originally known as Hagen's Opera House and later known as the New Grand after it was remodeled, the theater offered everything from Shakespeare to popular singers. In the early 1900s, it became a silent movie theater before burning in 1924. The Dunhill Shirt Company factory was then built on the site.

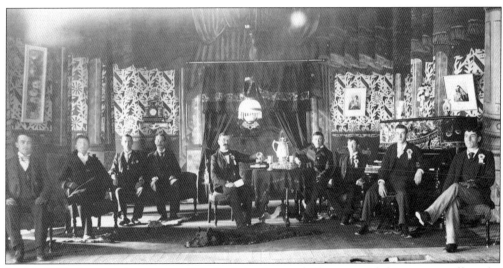

In this 1893 photograph, manager E.A. Ludwigs (center left) poses with his young staff on the elaborate stage of the New Grand Opera House. Note the bearskin rug at his feet and the other pelts on the floor. Although the opera house was putting up a good front of being prosperous, around 1900 it was converted to a silent movie theater, with a popcorn wagon parked outside.

These two photographs of entertainers present a real contrast. The group above, in their pseudo–African American wigs and blackface makeup, appear to be onstage at the Grand Opera House. They likely performed a musical comedy act there. Their names are listed as, from left to right, Ed B., Linc, Ben, and Joe. The group below, known as the Excelsior Band, is a successful touring band that probably could only appear in black venues or perhaps white nightclubs or saloons at that time. From left to right, they are (first row) Lincoln Jones, George Henry Robinson, Robert "Frog" Lindsey, and George "Bucky" Robinson; (second row) Charles Hagwood, ? Slaughter, Buster Miller, unidentified, Smith Mady, Denver Pyle, and William Hagwood.

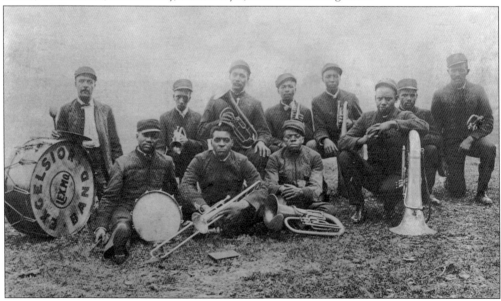

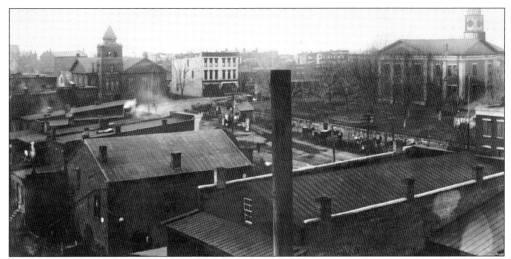

Taken in the late 1800s from the water tower of the Hoffman Brewing Company, this photograph shows the city market to the right and scales to the left, behind the courthouse. The brewing company was founded by Ernest Hoffman Sr. in 1875 and produced 1,300 barrels of beer in 1880. By 1912, he had added an ice plant and leased the business, which was by then producing 50 barrels of beer and 50 tons of ice per day.

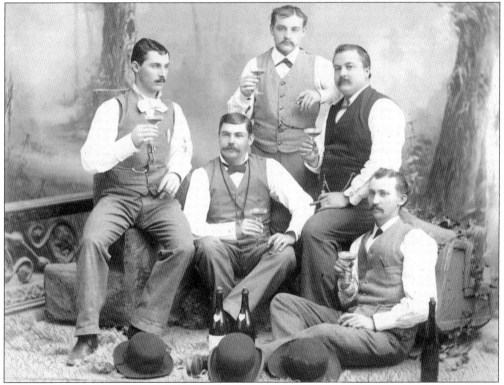

These five unidentified young men about town would seem to be likely customers for Hoffman beer. However, they are posed drinking wine and smoking cigars in a photographer's studio, possibly to show their good taste or to celebrate some occasion. Their clothing, including derby hats and vests with watch chains, indentifies them with the rising middle class in Lexington.

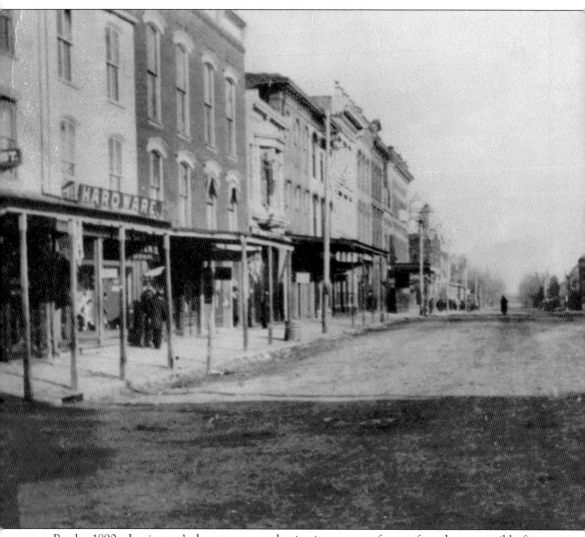

By the 1890s, Lexington's downtown was beginning to transform, often due to terrible fires, into a truly Victorian cityscape. Note the multicolored paint scheme on the courthouse and the bandstand on the lawn. Also note the storefront to the left with the cast-iron oriel window

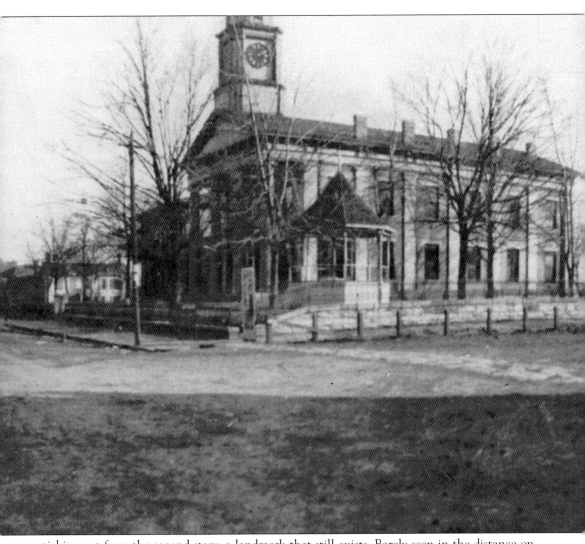

sticking out from the second story, a landmark that still exists. Barely seen in the distance on the left is the new Traders Bank.

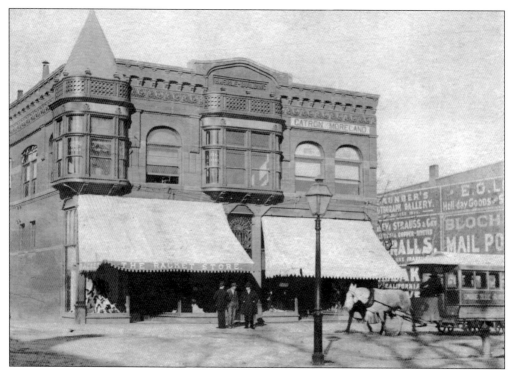

Traders Bank was established in 1892 in this Romanesque Revival/Queen Anne–style building, but it combined with the new Commercial Bank after 1912. The Racket Store, seen here, sold high-quality clothes and other goods. It burned in 1937 after it had become a Great Atlantic & Pacific Tea Company (A&P) grocery store. The horse-drawn vehicle to the right is one of the omnibuses that replaced the trolleys after 1899.

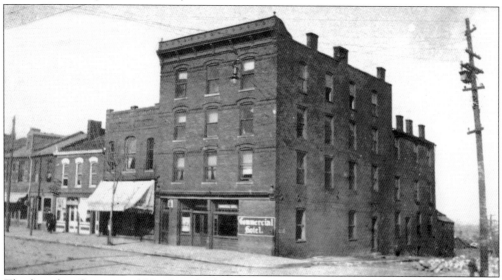

The first-class Commercial Hotel was built soon after the Civil War at Twelfth and Main Streets, but it was remodeled in 1879, and it included a ticket office for the narrow gauge railroad to Kansas City. The hotel burned to the ground in 1907, after which John Hix built the two-story Hix Building, which still stands, for the Hix Brothers Store.

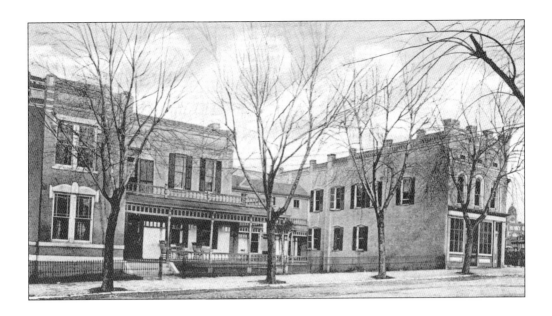

As people were used to staying with relatives when they traveled, hotels were often given a family flavor. Such was the case with the Nickell House at Eighth Street and Broadway, which expanded around the original Nickell family home, seen here with the porch in the middle. It came to include buildings to the left and the right. The hotel is seen below after it was remodeled in the early 1900s by D.C. Morris, who ran the Lexington Hotel until 1950, when it was taken over by Lloyd and Esther Cameron and later demolished. Below, the building to the far right was where the Aull Savings Bank was started in 1843 by Robert Aull. He and his brother James began taking deposits at their store in Old Town as early as 1829, which is considered the beginning of banking in western Missouri. The Aull Savings Bank closed in 1870.

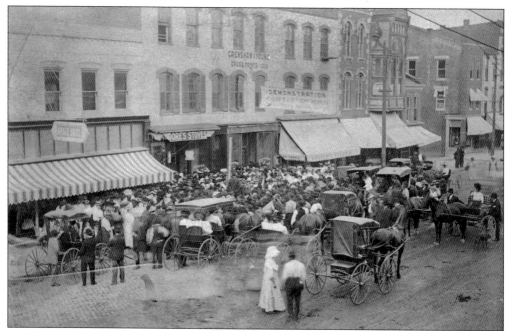

In 1893, J.G. Crenshaw and Albert Young, after working for the Tevis and Loomis drugstores, started the Crenshaw & Young drugstore on Main Street. Here, around 1900, according to the banner stretched from their store to the electric pole, they were giving a demonstration of stoves that gathered a large crowd. Note the former Russell, Majors & Waddell building on the near corner to the right.

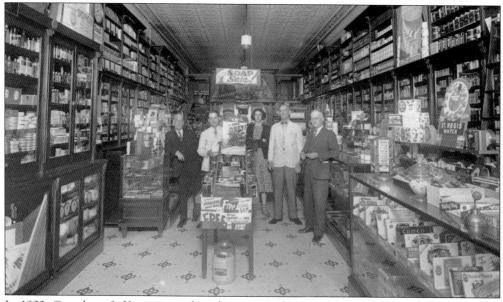

In 1903, Crenshaw & Young moved to the corner of Eleventh and Main Streets. Its building burned in 1908, but the store was back in business in a temporary location in 48 hours. When the block was rebuilt, it reopened, and this photograph was taken around 1910. In it are, from left to right, J.G. Crenshaw, Walter Rush, Mary Ford, Roy Ford, and Albert Young. In the early 1940s, the business was bought by Rush and the Fords.

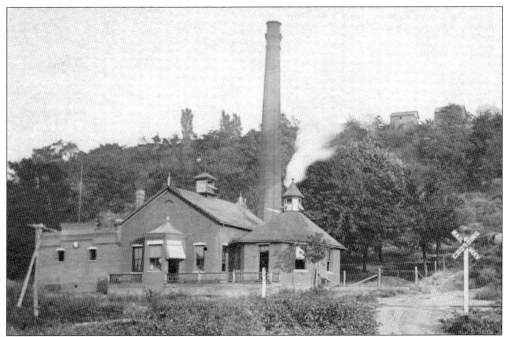

Before 1884, residents got their water from wells and cisterns. Then, the Lexington Water Company built this waterworks with its own power plant on the old landing. In 1886, a settling basin was added to reduce the amount of sand and sediment in the water. In 1903, Gustav Haerle bought the company and starting taking water directly from the river. Now owned by the city, this building is still in use.

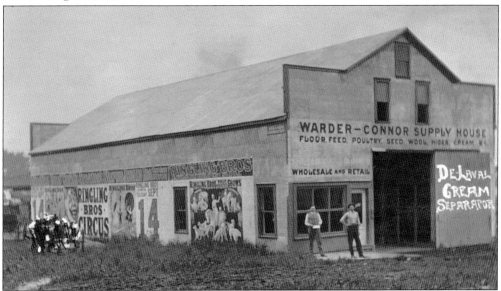

The Warder-Connor Supply House was owned by Walter Warder and Lester Connor, probably standing in front. It advertises flour, feed, poultry, wool, hides, and cream at wholesale and retail. The words "DeLaval Cream Separator" are written on the photograph to the right, referring to the separation of milk from cream. Note that the Ringling Bros. Circus was coming to Lexington on September 14.

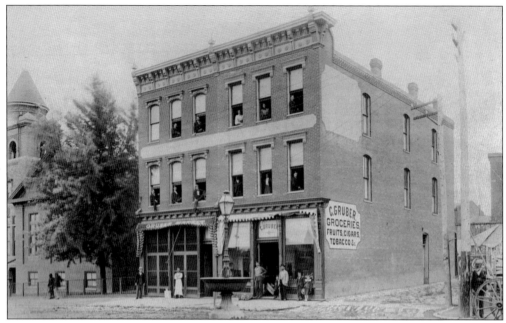

One of about 20 neighborhood grocery stores, this one on Ninth Street was owned by Caspar Gruber. This 1895 photograph likely shows the family and other workers, many of whom probably live upstairs, which was common in those days. This building had many other owners, including Louis Gruber, when it was the Beehive Store, and William Palmer Sr., when it was the Labor Exchange and the Palmer Saloon.

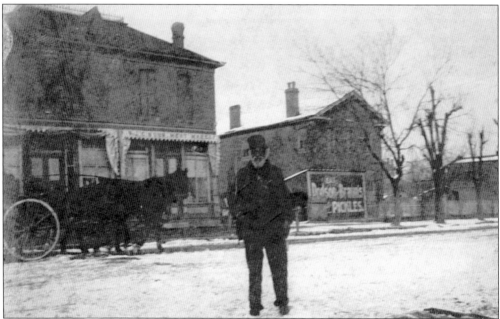

The W.J.C. Bour Meat Market, at Eighteenth Street and Franklin Avenue, was another neighborhood grocery store, specializing in meat. The store's delivery wagon is parked in front of the store. The man in the photograph is likely an employee of the market. The store building still stands, but the house to the right is gone.

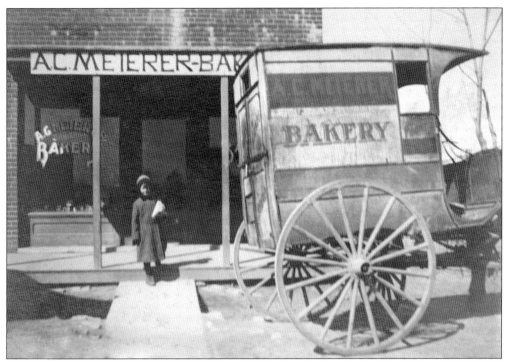

The A.C. Meierer Bakery was on the south side of town on Twentieth Street, also known as Old Independence Road. In those days, almost everyone had to deliver his goods if he wanted to stay in business, since taking a horse, wagon, or buggy to a store was a lot of trouble for customers.

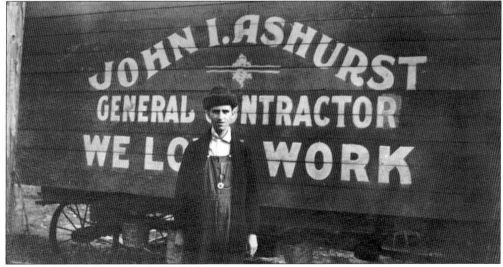

Not all businesses needed a store building. In the late 1800s and early 1900s, John I. Ashurst did his general contracting out of his large wagon, which made good business sense. His catchy slogan, "We Love Work," indicates that he had at least one helper.

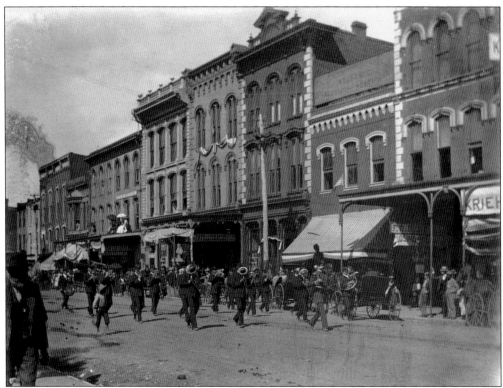

The bunting and the American flag in the window of the *Intelligencer* offices (center) indicate that this may have been a Fourth of July parade. The band was probably one of several local brass bands. Note the ladies with parasols watching from the porch roof of the Tevis drugstore (upper left), and the boy following the band on the lower left.

Troops carry rifles and wear tropical uniforms as they either leave for or return from the Spanish-American War in 1898. Note the trolley and tracks, which were removed in 1899.

Five
HEIGHT OF PROSPERITY

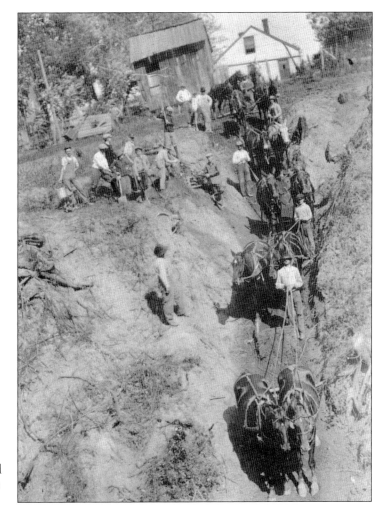

In 1913, the people of Lexington and the surrounding area banded together to turn a swampy hollow called the Goose Pond into a playing field and a swimming pool. This task required a lot of men, horses, mules, and boys to cut down a large hill overlooking the pond area. It also required a lot of support from the women of the town, who supplied food, medical care, and moral support. In the end, the effort was successful.

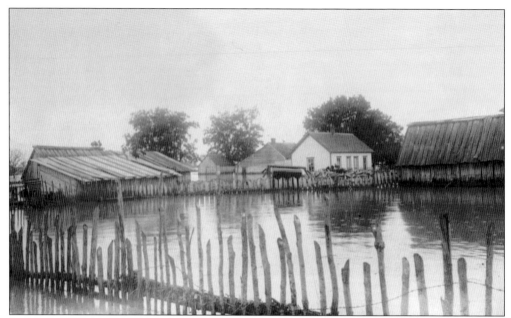

Lexington had a major flood in 1903. Since one of the two major railroad lines and its station, the water plant, many houses, and much farmland were located in the quarter mile from the bluff to the riverbed, much of the town was affected. As seen here, many of the farms in what was known as the bottoms had no defense against flood.

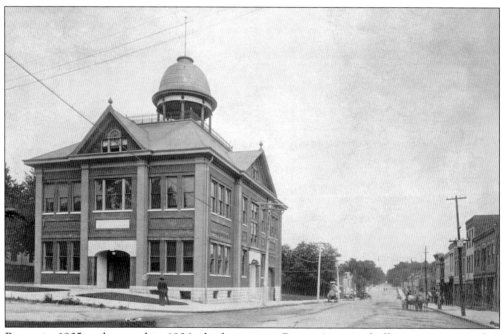

Begun in 1905 and opened in 1906, the large, new, Beaux-Arts city hall was a sure sign that Lexington had regained its pre–Civil War prosperity. It featured a lighted "floating" dome on pillars with an observation deck, a fire station, a ballroom on the second floor, and the city jail in the basement, plus many offices and a courtroom.

By about 1910, a large bandstand and park (pictured) were added to the lot behind the 1905 city hall. Later, in the 1930s, that area was chosen as the site for the Lexington Municipal Auditorium. With its yellow brick and Art Deco style, it created quite a contrast with the city hall building. Note the Presbyterian church to the left, and the man changing a tire in the lower center.

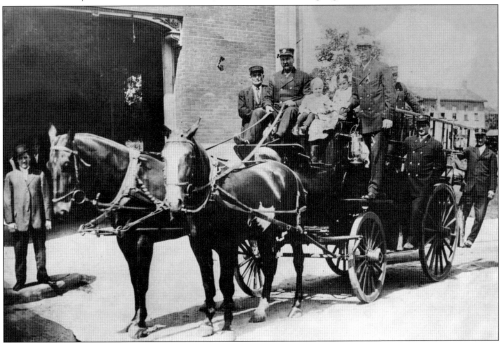

The new city hall included the fire station, and its large, decorative doorway is seen here. Horse-drawn vehicles were used by the Lexington Fire Department until 1914. This photograph shows, from left to right, Mickey Blee, unidentified, driver Lon Menaugh, Jim Menaugh Jr., unidentified, Jim Menaugh Sr., unidentified, John Menaugh, and unidentified.

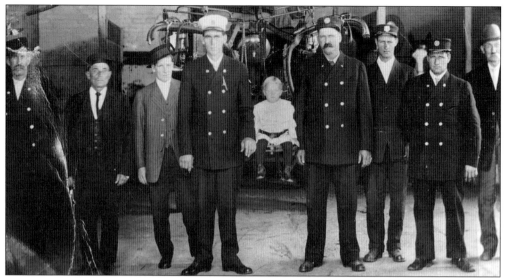

This photograph was taken inside the fire station at city hall before 1915. It shows, from left to right, two unidentified men, Felix Buellens, Jim Menaugh Sr., Jim Menaugh Jr., Lon Menaugh, and three more unidentified men. The horses, such as the one in the right background, were kept in stalls at the back of the station. At the sound of the fire bell, they were trained to run under the harnesses seen in the middle.

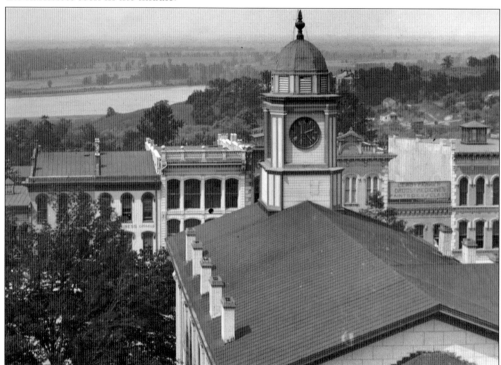

The observation deck under the dome of the new city hall was popular with sightseers and photographers. This shot gives a close view of the roof and clock tower of the courthouse. The four-faced clock with chimes was added in 1886, funded solely by donations from residents. Notice the accent color on the tower and the faux stonework on the rear of the building.

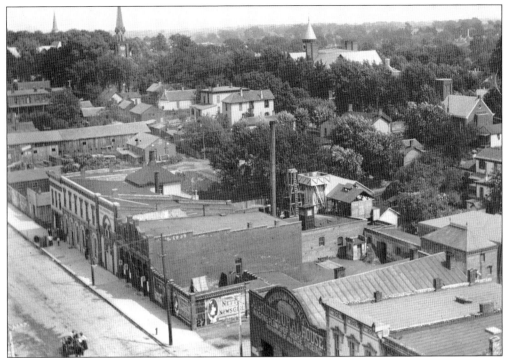

Looking southeast from the roof of the city hall, the view in this photograph shows the tower of the high school in the upper right and the water tower of the Hoffman Brewery in the lower right. In the lower center is Nickleson & Bartell's Agricultural House, advertising wagons, plowshares, horseshoeing, and repairing of all kinds. In the upper left is the Christian church steeple, with the Methodist church steeple to its right.

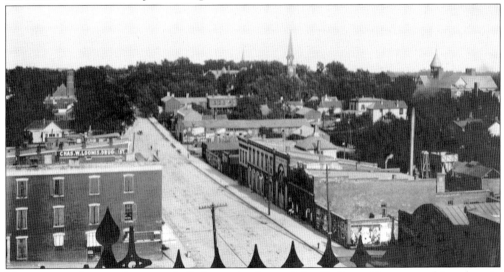

This view to the east from city hall shows the front of the Hoffman Brewery and ice plant in the lower center. The long building in the middle center is a livery stable, and, beyond that, on the corner of Thirteenth Street and Franklin Avenue, is a pre–Civil War brick house with a large extension to the right. The Loomis drugstore is in the lower left. That building remained a drugstore until 2010.

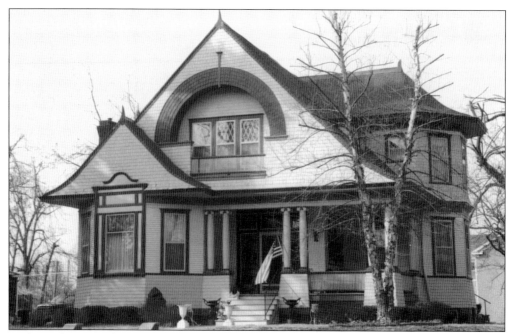

In the early 1900s, the new Shingle Style architecture began to appear in Lexington. It featured wooden shingles on large areas of its exterior walls, graceful arches, and large bay windows. All of these features can be seen on the Tempel house, built in 1906 at Seventeenth and Main Streets. The roof shingles also form decorative patterns.

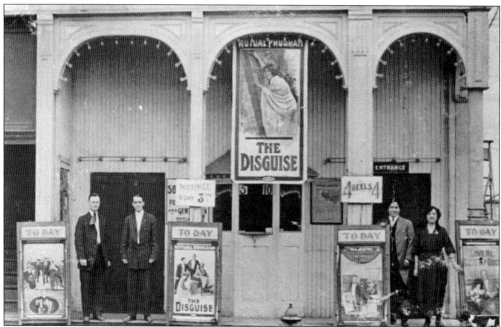

The silent movie theater was a new type of business that appeared in the early 1900s. This one was located on the southeast corner of Eleventh and Main Streets. The single cast-iron column on the right corner is still a feature of that building, which is now a law office. The Grand Opera House also became a movie theater, as did the Eagle Theater, one block west of the courthouse.

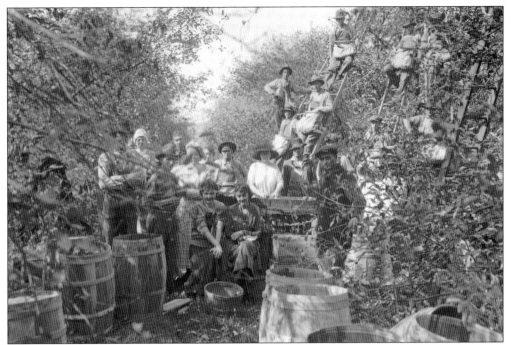

The loess soil in northern Lafayette County is some of the most fertile in the world. By the 1920s, when this photograph was likely taken, there were dozens of large apple orchards in the area. Since pickers were usually members of the owner's family or seasonal workers, the women in this photograph are probably wives, girlfriends, or relatives who brought lunches and helped with the picking.

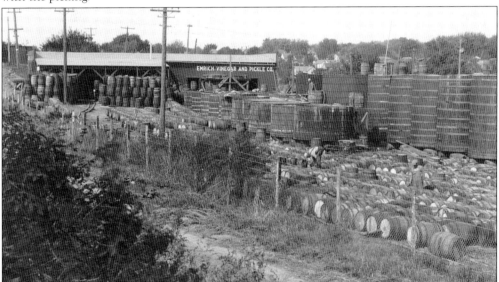

In the early 1900s, many of the poorer-quality local apples were made into vinegar at the Emrich Vinegar and Pickle Company in Lexington. As the name implies, it also bought a lot of cucumbers from local farmers. Most of the vinegar and pickles were packed in barrels and kegs after being processed in the large vats to the right. The company's location is not known, but it would have been near one of the railroads for shipping.

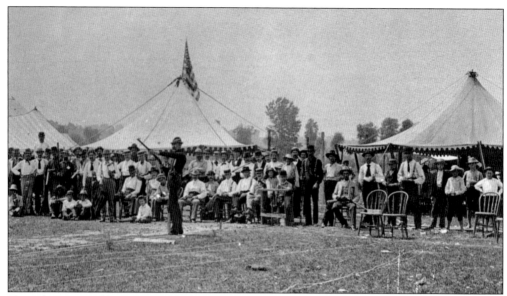

Skeet shooting and hunting were popular in the area. Here, the local hunting club hosts a shooting demonstration or contest. The crowd includes Karl Hammer, who may have been the county sheriff at the time. He is not identified specifically. Hammer, who was also a local historian, collected many of the photographs seen in this book.

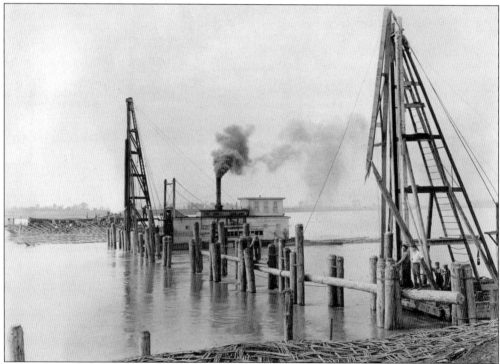

Soon after 1900, the US Army Corps of Engineers was ordered to begin narrowing and deepening the channel of the Missouri River with wing dikes of posts. They are seen here being driven into the water by the *U.S. Engr. Dept. No. 5* steamboat. The shores were covered with reed mats to prevent soil erosion. This process continues today, using stone dikes and plastic mats on the shore.

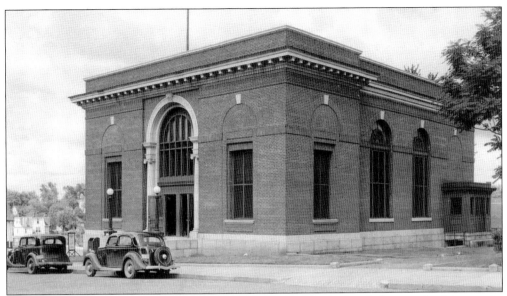

One of the earliest postmasters of Lexington was James Aull, who handed out mail at his store. In 1912, this new post office was built at Thirteenth and Main Streets. It included a full basement and a second story that circled the large lobby over each room below. Peepholes allowed the postmaster and postal inspectors to view each room, even the employee bathroom—at the time, all employees were males—to catch misconduct.

This area, known as Goose Hollow, often held shallow water and was known as Goose Pond. It was often skated on in winter. North of Main Street, just three blocks east of the courthouse and two blocks south of Central College, it was an overgrown eyesore and a source of mosquitoes. In 1912, a group of community leaders drew up a plan for turning the area into a playing field and a swimming pool.

Although the standing water in Goose Hollow was called the Goose Pond, after a period of heavy rain, it became more of a lake, as seen here. The first step of the plan to reclaim the area for a playing field was to publish a pamphlet outlining the ambitious plan and asking for financial support. The names of individuals and companies who donated were printed in the newspaper.

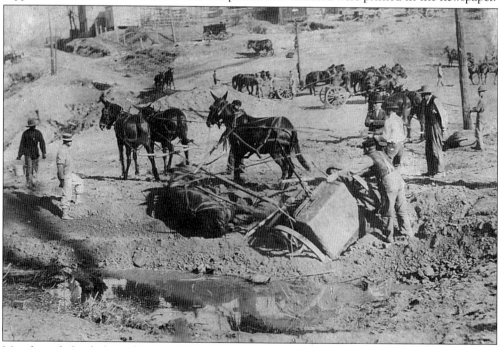

Mainly with funds from the organizing committee, the 4.5 acres targeted for development were purchased in the winter of 1912. By spring, more than $6,000 had been raised, and men were hired to clear away the trees and brush. Workers with teams and equipment then began to dig away dirt. Some accidents occurred, as when this mule team attempted to pull an earth scraper.

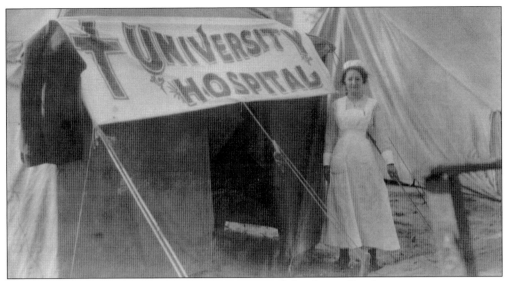

When accidents occurred during the excavation of the Goose Pond area, victims went to a first-aid tent, dubbed "University Hospital," probably because the hospital at the University of Missouri was considered the best. A nurse was there to treat the injured. Fortunately, there were few serious injuries, even though so many men were working with animals, axes, shovels, and heavy equipment.

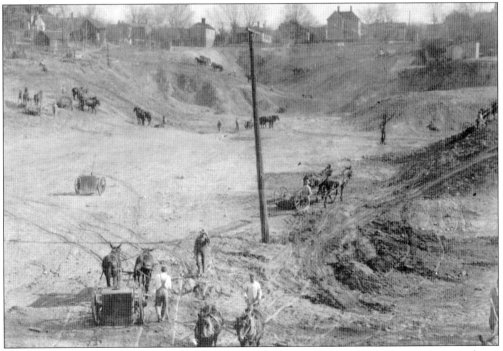

During the spring and summer of 1913, as men dug out and leveled the large area seen here, other men were hired to lay a drain pipe and rebuild a retaining wall along Sixteenth Street, 145 feet farther to the east. By that time, all the money raised had been spent, so a call went out for volunteers to finish the work. About 600 people showed up that first day, many of them farmers with teams and equipment.

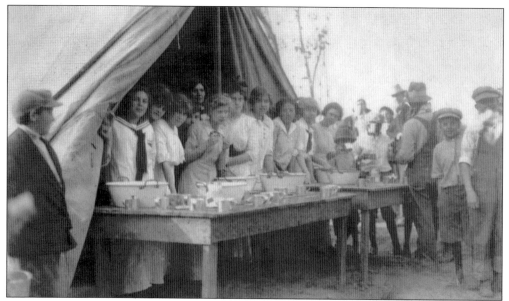

With hundreds of volunteers doing most of the work on the Goose Pond project in the summer of 1913, a lot of food was required, and the ladies of Lexington responded generously with desserts, while grocery stores donated other food, which was served on long temporary tables. Even the high school girls here helped, serving drinks to a lot of thirsty and appreciative men and boys.

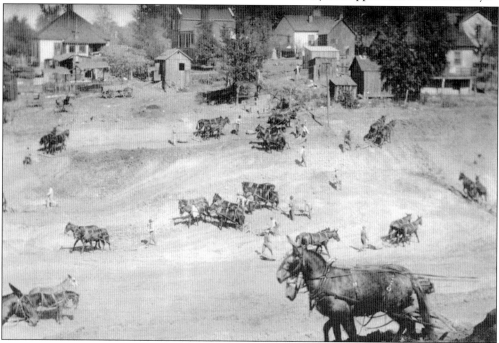

After days of work by hundreds of volunteers and up to 60 mule and horse teams, Lexington began to get national publicity, especially since the Goose Pond playing field was to be donated to the board of education. Work continued through the fall in shaping the playing field. As seen here, there were houses around the area, and several along Main Street had to be removed to make room for the field.

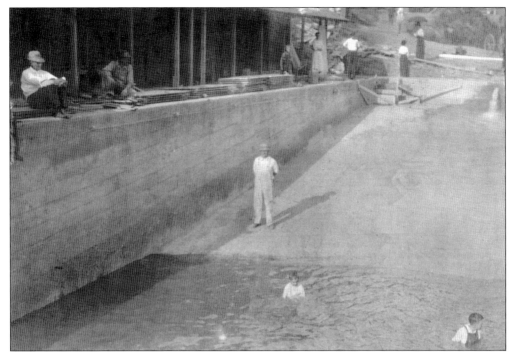

In May and June of 1913, the community swimming pool was built on the shelf of somewhat higher land along Sixteenth Street. It was 30 feet wide and 100 feet long, and it cost about $5,000. These boys could not wait to take a swim after a rain filled part of the unfinished pool, but the official opening was not until the summer of 1914.

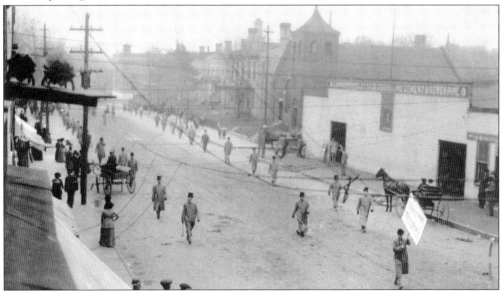

In the fall of 1913, it was decided upon to have two minstrel shows at the Grand Opera House in December to raise funds to complete the Goose Pond project. Business leaders and other volunteers were to put on the show. Minstrel shows were popular at the time, but today they are considered offensive, as all but the master of ceremonies wore blackface. Here, minstrel volunteers march down Main Street to help sell tickets.

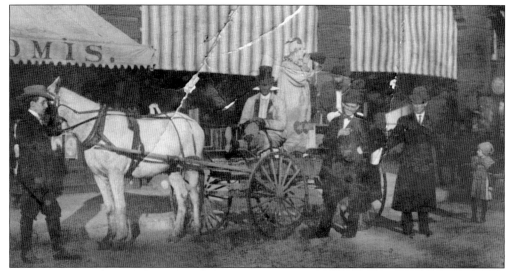

To further publicize the Goose Pond minstrel fundraising shows, promoters had this float in a parade. The master of ceremonies is seen here with a megaphone, telling about the shows to be held in December. According to participant B.M. Little Jr., in *Lexington, Missouri 1822–1972*, the shows had a "reputation for good taste" and "care was taken not to hurt anyone's feelings." However, it is not known what the African American community thought about them.

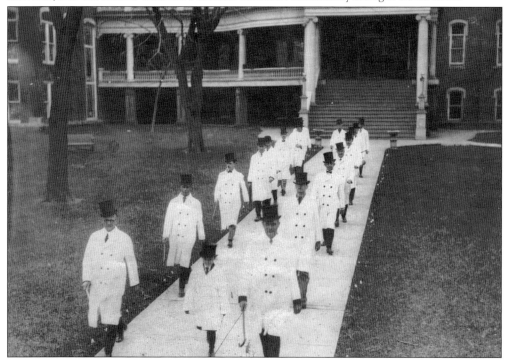

The Goose Pond minstrel shows were revived as fundraisers in 1915, 1916, 1932, and 1940. The minstrels are seen here in front of Central College, likely in 1932. Although enough money was raised to finish the playing field, a field house and tennis courts were never added, as had been planned. The 1927 Lexington Junior-Senior High School used the Goose Pond as the school's football field for many years, and it is still used for community activities.

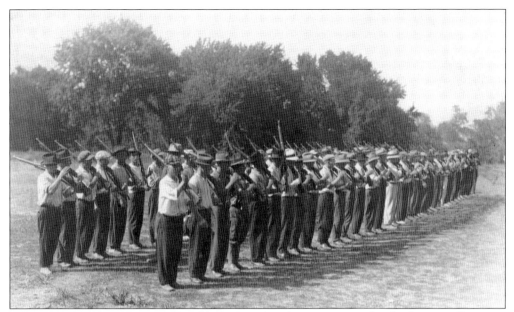

When the United States entered World War I in 1917, there were many local volunteers. Company A of the 35th Division is seen here training on the drill field at Wentworth Military Academy. James M. Sellers, the son of Col. Sanford Sellers, the first superintendent of the school, fought in France as a Marine, receiving the Silver Star. Later, he followed in his father's footsteps as president of Wentworth.

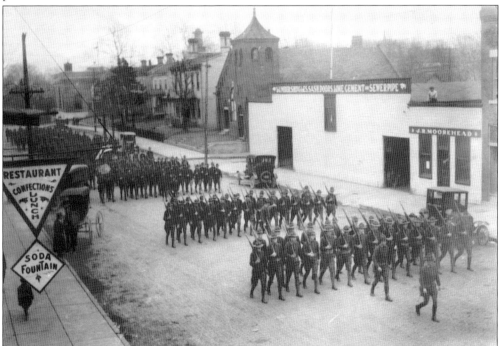

This photograph of Main Street in 1917 or 1918 shows local volunteer troops either leaving for or returning from France during World War I. The first Lafayette County soldier killed in the war was George Cullom of Lexington. The local American Legion Post is named in his honor.

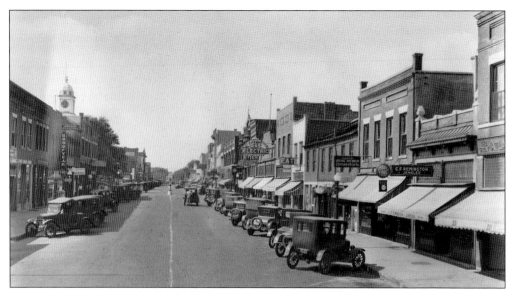

Main Street is seen here in the 1920s, looking west from Twelfth Street. The Great Atlantic & Pacific Tea Company (A&P), the first chain grocery store in town, is on the right. It later moved to the Traders Bank building, seen at the other end of the block. On the left, the Morrison Western Auto store has a Goodyear tire sign. Note the stoplight in the middle of Eleventh Street, in the distance near the courthouse.

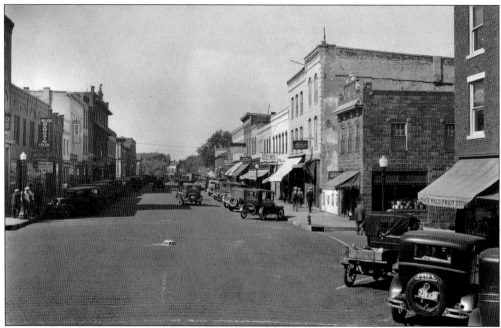

The view in this photograph looks west down Main Street from Tenth Street in 1928. The old Russell, Majors & Waddell building on the northwest corner, to the right, collapsed in 1926 and was replaced with a Spanish-style building. The second building to the right was used as the headquarters of Gen. Sterling Price during the Battle of Lexington. The largest building to the left was built by the Fraternal Order of Eagles in 1902, and it included a silent movie theater on the first floor. Note the new stop sign embedded in the pavement.

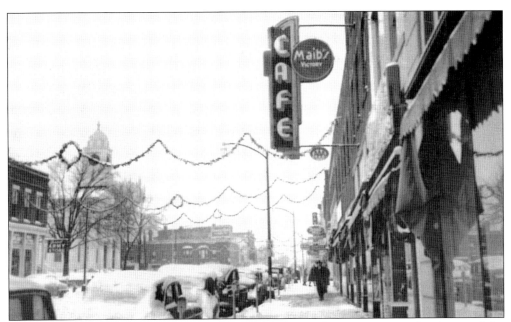

Following World War I, Harvey Mavel opened the Victory Restaurant, named in honor of the Allied victory in the war, in the north 1100 block of Main Street. A few years later, his brother-in-law Harold Maib became his partner. After Marvel retired, Maib continued the business as Maib's Victory Café, as seen here on the sign. This photograph was taken around Christmastime in the 1940s.

Harold Maib, the owner of Maib's Victory Café, which was commonly called "the Victory" or just "Maib's," is seen here with three of his cooks. People came from as far away as Kansas City to eat there. It was known for good food at reasonable prices, friendly service, and fresh flowers on the tables. A round table in the back became the gathering place for downtown businessmen.

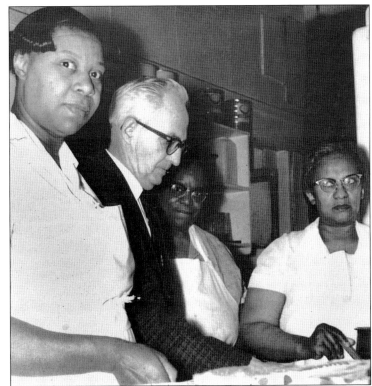

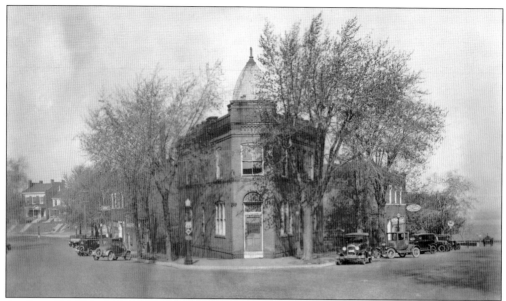

At the western end of downtown, Broadway splits off to the right from Main Street, leaving a triangular block. In the 1920s, most of the block was taken up with the Ford dealership, whose sign is on the right. At the point of the triangle was the unusually shaped home of the Haerles. This block was actually the first commercial block in town when New Town was laid out near the river landing in the 1830s.

This view looks west down Franklin Avenue from Thirteenth Street in the 1920s. On the right is the 1848 Christ Church Episcopal, and the 1905 city hall is in the distance, with its raised dome. The first building on the left soon became the headquarters of the Mattingly Brothers Company, a chain of dime stores. The "Sixty Six" sign refers to Phillips 66 gasoline, which was sold at a service station on that corner.

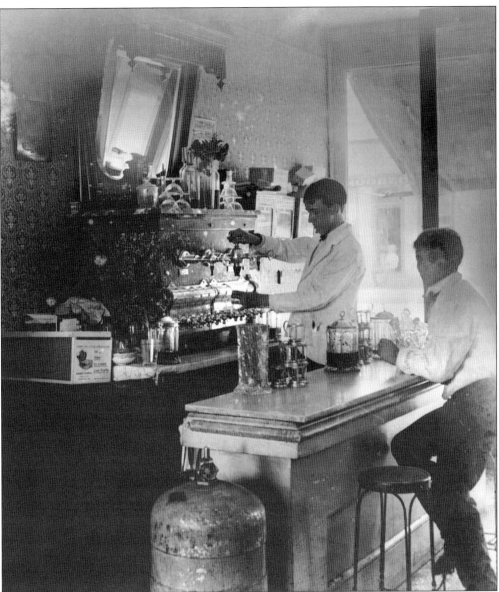

By the 1920s, soda fountains, where drinks were mixed and served on demand, were very popular. By 1912, Lexington had at least four of them. They included ones at the Barron & Sheets Restaurant, the Crenshaw & Young drugstore, Marshall's drugstore, and Hinesley's Restaurant. Hinesley's is described in *A Pictorial Souvenir of Lexington* as having "a large soda fountain and delicious ice cream." This particular fountain is not identified, but it is typical of what most of them looked like.

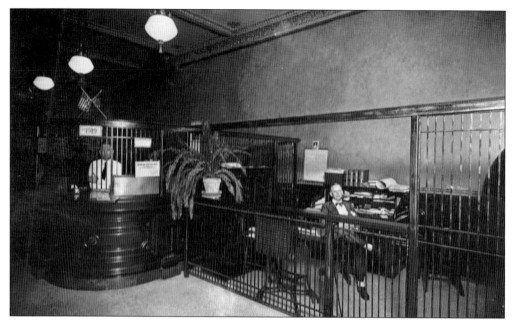

Tellers at the Lexington Savings Bank, across from the courthouse, pose behind the counter. This bank began in 1869 to take over the accounts of the Farmers Bank, which was being closed. In 1928, it merged with the Lafayette County Trust Company to form the Lexington Savings Trust Company, which changed its name in 1963 to the Lexington Bank & Trust Company. It was bought out by Commerce Bank in the 1980s.

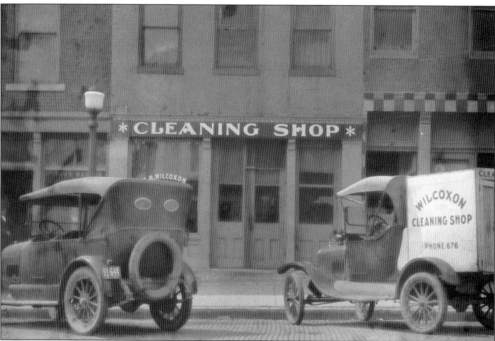

The Wilcoxon Cleaning Shop was on the south 1000 block of Franklin Avenue. The dry cleaning and laundry establishment was owned by Cincinatus Wilcoxon. It was later taken over by Herb Shenck, and stayed in business until the 1950s.

Long's Meat Market was operated by Joe Long at 906 Main Street. Most grocery stores, other than the W.J.C. Bour Meat Market, preferred not to sell fresh meat due to refrigeration needs, so specialized shops emerged as electric refrigeration became available.

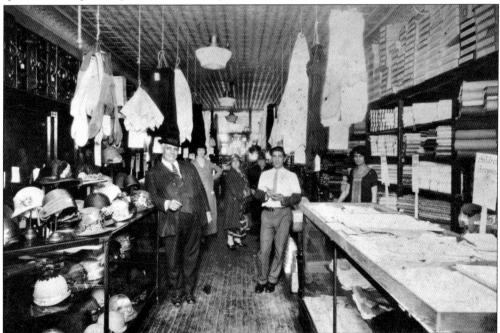

By the 1920s, a wider variety of immigrants were entering the area. One of them, George Nasser, a Syrian immigrant, opened a popular clothing store on Twentieth Street. He is seen here on the left, along with some members of his family and some customers.

Although there had been German Lutherans in the area for many years, they had had to go to services in other communities until 1924, when this white stucco church was built at Fourteenth Street and Franklin Avenue. In 1965, the congregation built a new church on the south side of town. This building then served the First Church of God. Today, it is home to the Restoration Branch of the Church of Jesus Christ of Latter-day Saints.

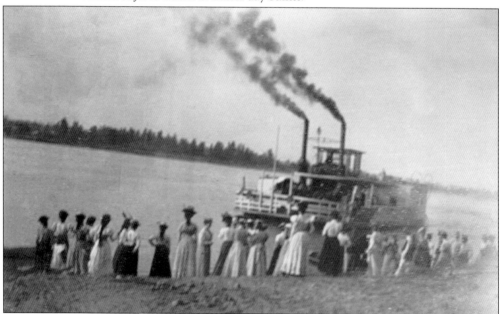

Since the failure of the pontoon bridge in 1890, Lexington continued to depend on ferryboats to cross the river to Richmond and beyond. The *Ariel* is seen here in 1895. It was swept away in the flood of 1903, but soon replaced. Local businessmen were continually looking for a way to build a modern bridge, but the process took a long time.

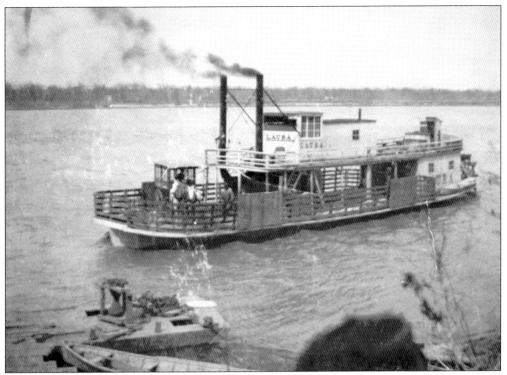

The ferry *Laura* prepares to dock at the Lexington landing after making a trip to the north shore. In 1895, the Lexington Bridge & Transfer Company was formed to convince the Santa Fe Railroad, which ran north of the river, to build a bridge. Unfortunately, that effort failed.

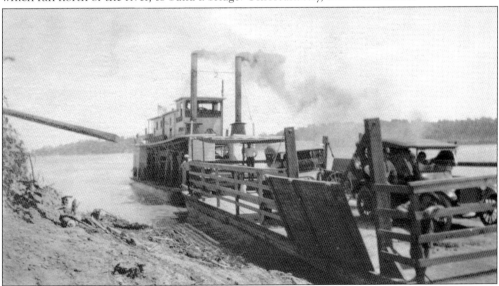

This 1917 photograph shows an unnamed Lexington ferry pushing a barge with two early cars across the river. In 1922, the chamber of commerce appointed a committee to see if the state highway commission was willing to build a free bridge across the Missouri River as part of its highway expansion program. The highway commission agreed to provide half the estimated cost of $900,000, using federal highway funds.

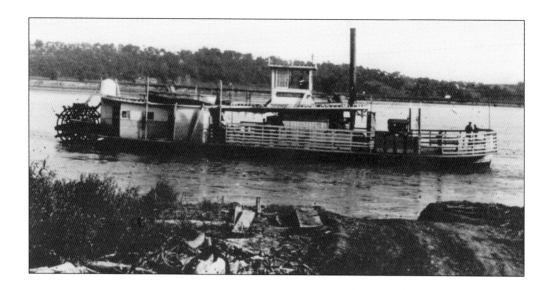

The *Lexington*, owned by Tilton Davis, was the last ferry based here. For a brief time, it was used at Wellington, a few miles upstream, and then it was sold for use on the Illinois River. In order to raise $450,000 to pay their half of the cost of a steel-and-concrete bridge across the Missouri River, bond issues were quickly passed by Lafayette and Ray Counties in September 1922. Construction was a long, slow process, but in a grand celebration, the Lafayette–Ray County Bridge opened on November 5, 1925.

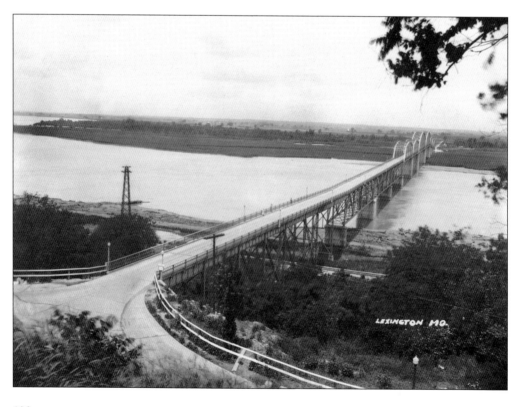

When the Lafayette-Ray County Bridge opened in 1925, a new section of highway, with a concrete guardrail, was built to provide access to the bridge. The Lafayette County World War I Memorial was installed facing the bridge entrance. Visitors driving on the new highway had a good view of the Madonna of the Trail, and she had a good view of the new bridge.

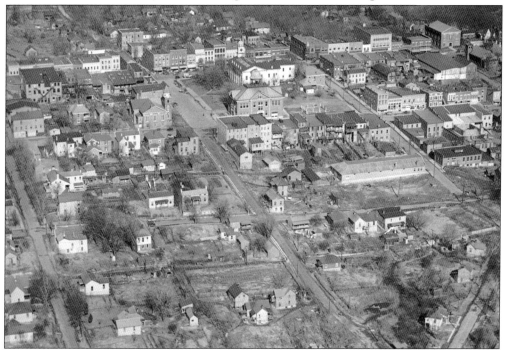

This aerial shot was taken in the late 1920s or early 1930s. In the upper right is the Baptist church, minus its bell tower, and at the right center is the long mule auction barn. In the upper center are the Traders Bank building, the courthouse with the name Lexington written on its roof, and the city hall with its dome. In the left center is the Presbyterian church.

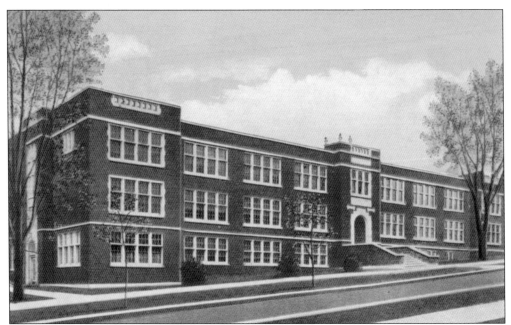

Lexington Junior-Senior High School opened in 1927 on the higher ground at the east end of the Goose Pond park. Its main entrance, shown above, was on Main Street. The Goose Pond playing field was used as a football stadium and physical education area, with concrete bleachers being added by a Works Progress Administration (WPA) work project in the 1930s. The pool built in 1913 was replaced by the 1950s with a vocational agriculture building and tennis courts. The photograph below shows the school in the 1990s, when it had become Lexington Middle School and the main entrance was on Sixteenth Street. The building was vacated and demolished in 2005.

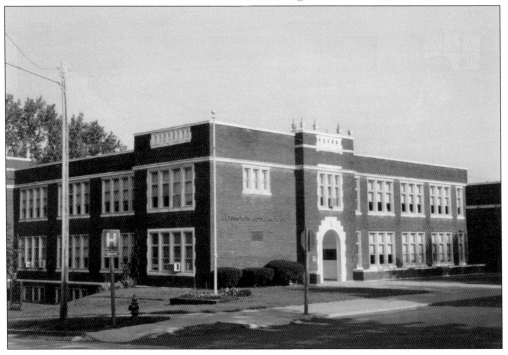

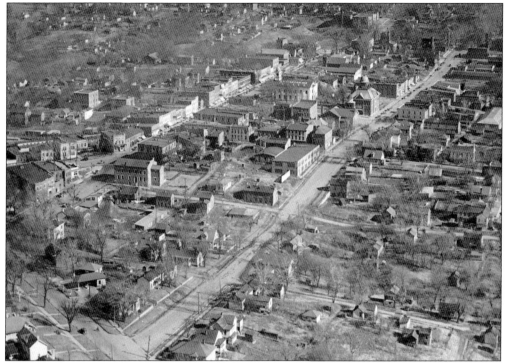

This aerial view from around 1930 shows Main Street to the left and Franklin Avenue to the right. At the top, going from right to left, are the steeple of the Catholic church, the high school on Main Street, Hickman Hall barracks at Wentworth Military Academy, and the shortened tower of the Zion African Methodist Episcopal Church. In the center, along Franklin Avenue, the large rectangular building became the home of the Dunhill Shirt Company in 1937.

With the 1920s came Prohibition, but Lexington was never fully dry, as there were stills like this one all over the area. This particular still was uncovered northeast of town, but other stills were in the woods along the river bluff and on islands in the river. Although official corruption was denied, the police sometimes seemed to have a hard time finding them.

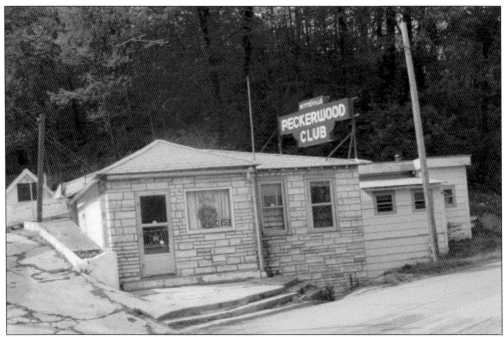

Mittieville started in the 1920s as a country grocery store a few miles west of Lexington on what is now Missouri Highway 224. However, the Peckerwood Club, as it was better known, soon became a popular roadhouse where liquor could be found quite easily. The club was built over Simpson's Santa Fe Trail spring, which served the establishment until it closed for good in the 1980s.

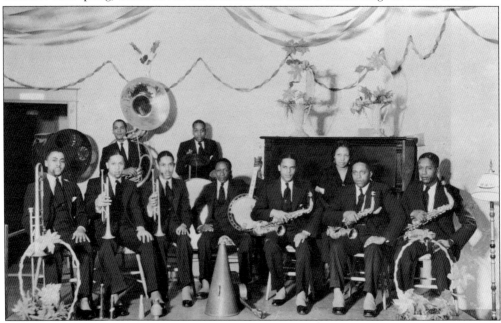

A band that might have played at the Peckerwood Club, but was more likely to have played in the Kansas City area when they were not at home in Lexington, was Elmer Radd's Cotton Club Orchestra. They often played on Block 42 in Lexington, along with such stars as Count Basie. The band was active until the 1940s.

The Eagle Building, to the right of the "keyhole building," was built by the Fraternal Order of Eagles Aerie No. 243 in 1902. It rented out the lower floor to the Eagle Theater, which showed silent movies and then sound films until the 1940s. The Eagles reportedly did not give up their liquor during Prohibition.

In 1929, federal agents raided the former Hoffman Brewing Company at Eleventh Street and Franklin Avenue. The people running the illegal distillery had a fur business as a front. They would buy furs and display them in the windows, claiming to be processing the furs in the old brewery. When the agents broke in, they found these six vats, each 35 feet long and 8 feet wide, with 30,000 gallons of mash.

When federal agents raided the old brewery, they also found several large copper stills like the ones seen above. They had a capacity to produce 1,000 gallons of whiskey per day. The criminals seem to have been warned, as they escaped through the trap door seen below and none were arrested at the scene. However, a few months later, the boss was arrested in California.

Six
DEPRESSION AND RECOVERY

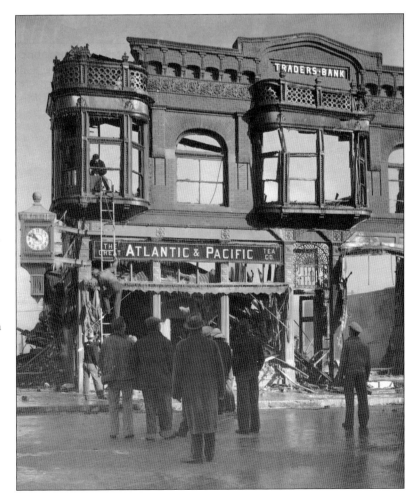

The 1930s was another time of transition, as demand for soft coal was declining, farm prices were low, and many businesses closed. The fire that took the Traders Bank building in 1937 seemed to mark the end of an era. Lexington had to build on its strengths to maintain a good quality of life. This approach worked well, and Lexington maintained its population, its services, and its pride.

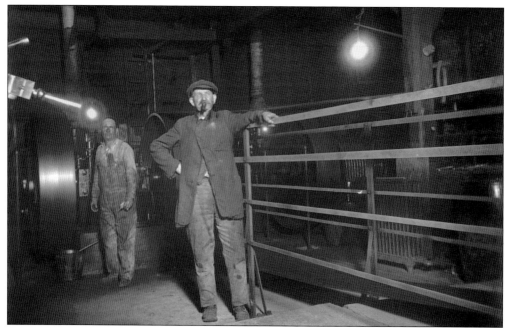

For many years, companies produced gas and electricity locally, providing work for men like the ones seen here in the electric power plant operated by Lexington Gas & Electric Company. However, with the construction of the bridge in 1925, a transmission line was able to bring in cheaper electricity from north of the river. In 1931, natural gas lines reached the area, and the coal-powered gas plant closed as well.

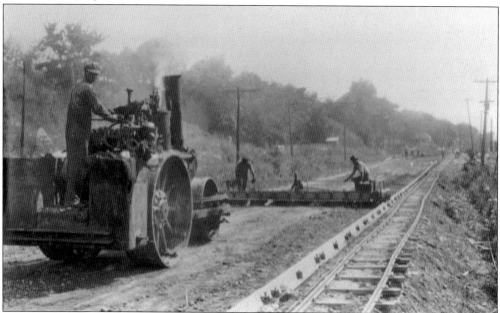

In the 1920s, Highway 13 was paved to the north as it crossed the new bridge at Lexington. By 1932, Highway 24 was paved to the east and west, making the town a crossroads of some significance at a time when there were no interstates. In this photograph from the early 1930s, workers level the US Highway 24 roadbed just west of town, near the Myrick train station.

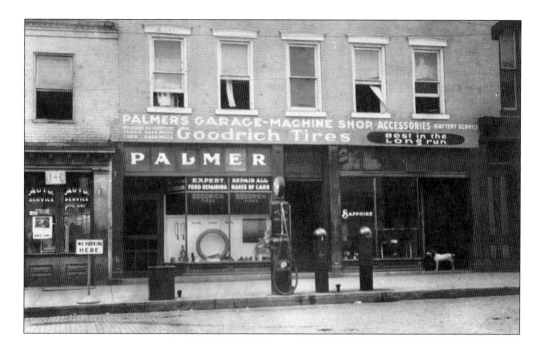

With all the improved roads came more cars, and, despite the Depression, more and more gas stations. Small older stations, like the single pump on Main Street at Palmer's Garage-Machine Shop (above), went out of business. Conveniently located next to the entrance to the bridge and in view of one of the main tourist attractions, is one of several new stations (below) going up. The sign advertises that it will sell Red Crown gasoline.

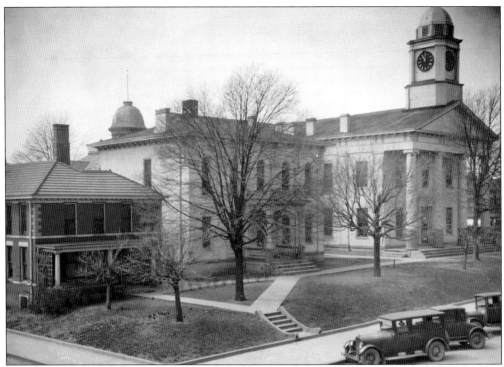

Even in hard times, the county buildings were maintained. The building to the left was the sheriff's house, constructed in the early 1900s right in front of the county jail. The middle building was the county clerk's office, which was expanded to two stories in the late 1800s. By the 1940s, it had been remodeled and connected to the courthouse. Note the color on the columns, which seems to go up about five feet.

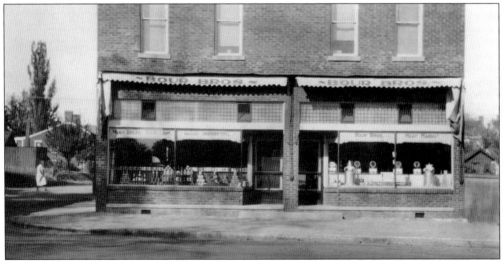

Everyone still needed to eat, even if on a smaller budget, so many neighborhood grocery stores, like the Bour brothers' store, survived. It was one of the largest, with a wide variety of services and goods, as displayed in the windows. At least one of the Bour families lived above the store, and they owned a duplex that their father had built behind the store, on Main Street, across from the Catholic church they attended.

In the 1920s and 1930s, large chain stores began to move into town, giving smaller stores stiff competition. The J.C. Penney Company store was located across from the courthouse until a 1957 fire.

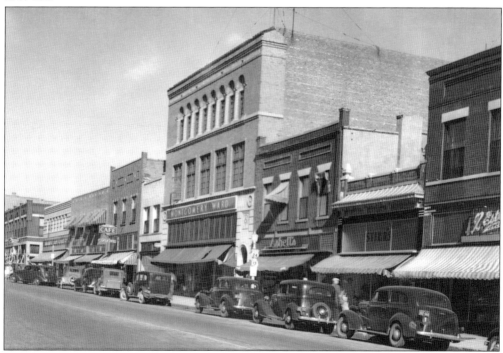

Montgomery Ward moved into the 1910 Masonic building, which was not only the tallest building in town, but also one of the largest, and the store seemed to sell almost everything. It continued in business until 1973.

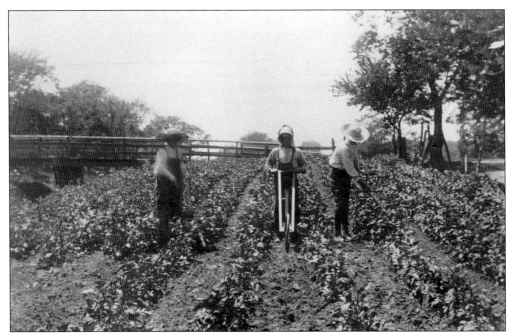

Most people had to take whatever work they could find, if they could find any work at all. These children are cultivating a large unidentified crop on land along the railroad tracks, probably rented from the Missouri Pacific Railroad. The Eighteenth Street Bridge over the tracks to Machpelah Cemetery is in the background.

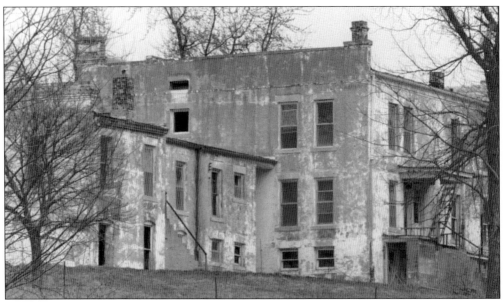

For those in poverty with no family to take them in, the county home and farm was about two miles southwest of town. Built in 1906, it was originally designed for about 20 residents, who were expected to help on the farm if they were able to do so. Despite federal assistance and meager county aid, the home was full during the Depression. It was closed by the 1950s and demolished in 2000.

Through a Works Progress Administration project, the Lexington Municipal Auditorium was built in the late 1930s behind city hall. The Art Deco style of the building is seen in the yellow brick, the lettering of the sign, the glass bricks around the doorway, and the rounded entry. Bob "Believe-It-or-Not" Ripley was part of the dedication ceremony. The building was neglected by the 1990s, but it is now being restored by community volunteers.

Hard times did not mean that people could not enjoy themselves. The people at this street fair in 1932 seem to be pretty happy, with 5¢ hamburgers and conversation. Behind the booth, a crowd appears to be gathered on the courthouse lawn.

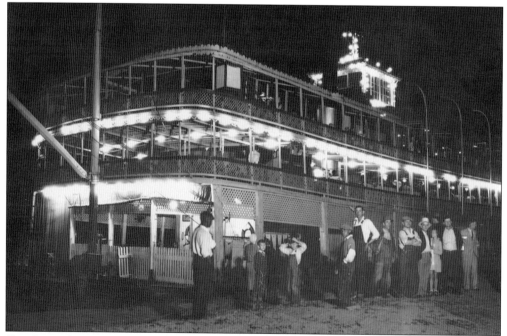

One form of entertainment that was rather unique to river towns was excursions on boats like the *Idlewild*, seen here stopping at Lexington for the night. These steamboats continued to travel the Missouri River until the 1940s, taking tourists from St. Louis, Kansas City, and Omaha to visit towns along the river, while providing shows for local residents like the ones seen standing in line here.

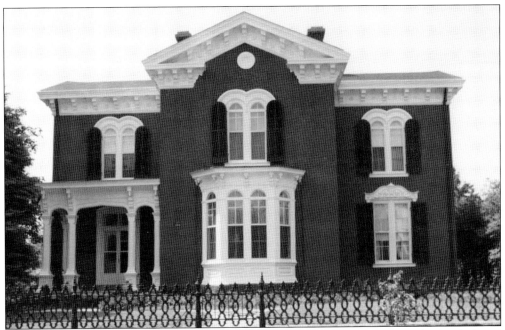

The Withers-Hogue-Stier house, built in the Italianate style around 1870, was the family home of Gen. William Hoge. During World War II, his engineering units built the Alcan Highway to Alaska, participated in the D-day invasion, and captured the Remagen Bridge across the Rhine River in the Battle of the Bulge. After the war, he commanded American troops in Europe before retiring to this home.

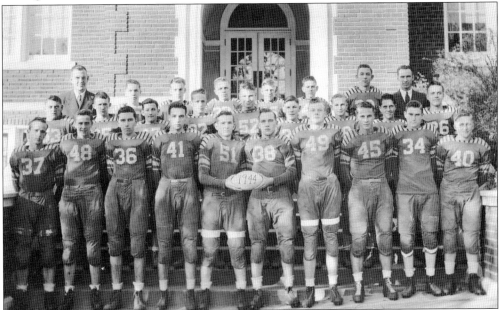

During the war, life went on pretty much as usual for high school students. Here, the 1944 Lexington Minutemen football team poses on the steps of the junior-senior high school after a successful season. Coach Amos Durrett is at the top left. Fortunately for these young men, World War II was almost over and more jobs were available.

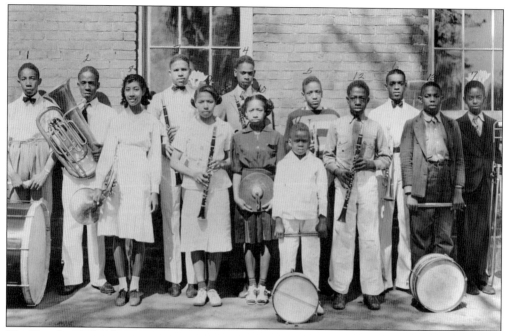

The Douglass School, at Fifth and Branch Streets, was named after famous abolitionist Frederick Douglass. The school band is seen above in 1942 in front of the school. The photograph below was also taken there in the 1940s. On the far right is coach Kermit Booker, and on the left is George Green, who was the principal for 50 years and never missed a day. In 1942, the new Douglass Elementary and High School was dedicated on Franklin Avenue. When the Lexington schools were integrated in 1956–1957, it became the middle school for the fifth and sixth grades.

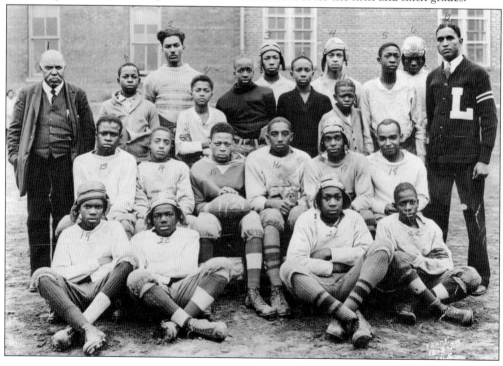

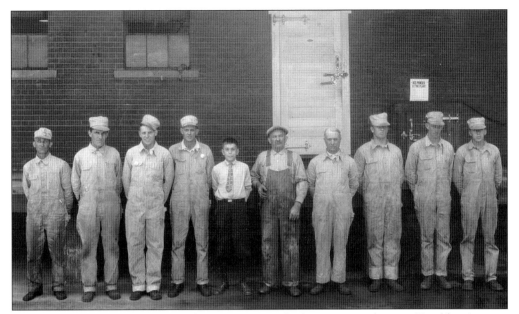

Around 1920, Lexington Gas & Electric Company built a new ice plant on Franklin Avenue, and it produced good profits even during the Depression. These ice plant workers in the 1940s are some of the last, as most people replaced iceboxes with refrigerators in the 1950s, resulting in the closing of the plant.

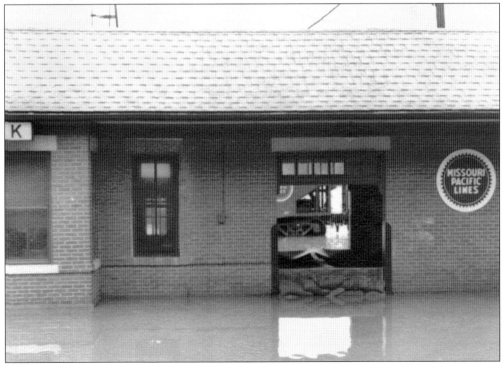

In 1951, another big flood inundated the bottoms along the river, stopping the Missouri Pacific trains that usually passed through the Myrick station. Fewer people had houses in the low areas than in 1903, but the water plant and many farms were still affected.

These two young ladies seem to be testing the depth of the water as they pose for the photographer. After the long-remembered 1951 flood, many measures were taken to avoid such damage in the future. The most effective was a series of higher earthen dams, or levees, built parallel to the river by the Army Corps of Engineers.

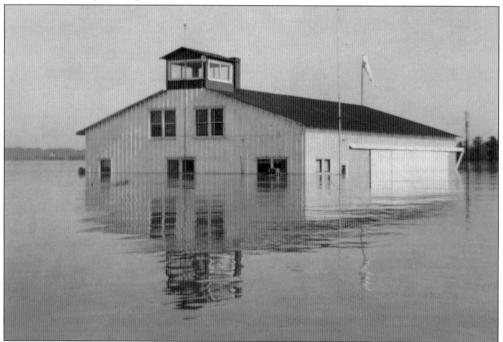

One of the biggest victims of the 1951 flood was the Lexington Municipal Airport, which the city had just taken over in 1946 from Wentworth Military Academy. The school had used its small airport in an optional program to train cadets as pilots, and then it trained naval aviators there during World War II.

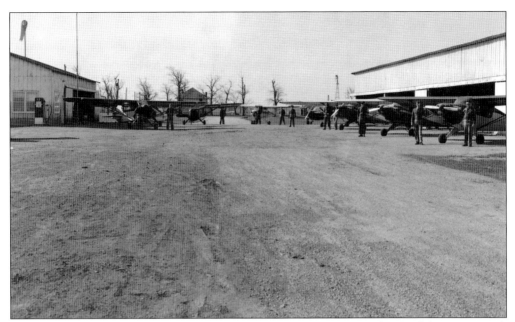

Lexington had to spend a good deal of money to repair the airport after the flood, but Wentworth cadets and others have continued to use it up to the present. Above, a group of cadets taking flight training stands at attention by the training planes. Below, the flight instructor explains something about the plane to a Wentworth officer and a cadet. Note the antenna on the plane. The program continues today through the school.

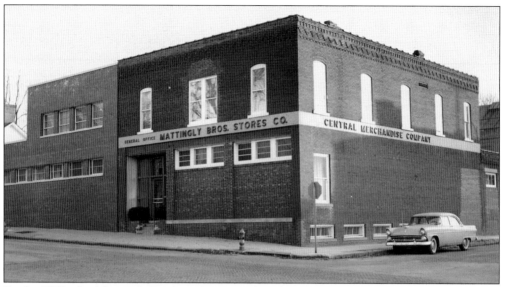

By the 1950s, the Mattingly Brothers Company, based in this building at Thirteenth Street and Franklin Avenue, had a chain of more than 30 dime stores throughout Missouri and was a major employer in town. Walmart founder Sam Walton may have picked up an idea or two from the business while he lived in Lexington. The company was sold to Place's in the 1980s.

Another prosperous company in the 1940s was the J.B. Russell Lumber Company, at Twelfth and Main Streets. It was one of two lumber companies in town at the. This convoy is hauling building materials for the construction of Whiteman Air Force Base.

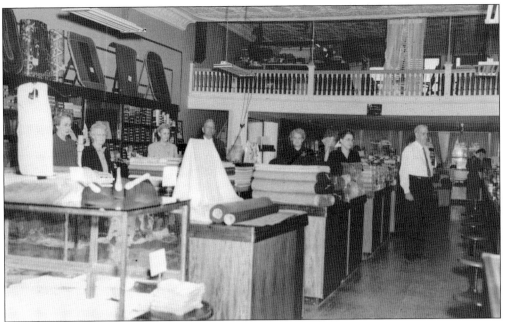

The Commercial Hotel, at Twelfth and Main Streets, burned down in 1907, but in 1908, John Hix built a new building and opened a general merchandising store with the help of his brothers Dow and Arch. Called Hix Brothers, it was in business until 1954. Seen here in the 1950s are, from left to right, Maud Hagood, Grace Eastham, Elizabeth Smith, John Hix, Effie Tegarden, ? Campbell, and Arch Hix.

An important part of the summer for many teenage boys in Lexington has been playing on a baseball team sponsored by a local business. Here, in the 1940s, the team sponsored by Ceno's Market poses for a photograph in the old baseball stadium. Ceno's was on Twentieth Street and owned by Ceno Giorza.

For many years, Lexington Scouting activities were based almost entirely at the Boy Scout cabin and at the Girl Scout building in Central College Park. These photographs show the annual awards being given at the Lexington Municipal Auditorium in 1955. Above, the members of Girl Scout Troop 12 receive pins for Tenderfoot and Second Class. Their leader was Effie Boldridge. Below, a troop of Brownies puts on what must have been a hilarious version of the Robin Hood story.

Circuses regularly visited Lexington for many years. At first, they came by train and set up at the fairgrounds near Old Town, but by the 1950s, when this photograph was taken, they were coming by truck. Here, at the west end of Main Street, with Highland Avenue in the background, Minera Estabrooks, a reporter and photographer for the *Advertiser-News*, feeds one of at least three hungry elephants.

This aerial view from around 1960 gives a good overview of the west end of downtown. In the center right, on Franklin Avenue, is the expanded Dunhill Shirt Company, known as Dunbrooke's after 1964. The white building in the left center is the Lexington Hotel, and in the lower-left center is the Mason Motor Company Chevrolet showroom and shop, in the long dark building, with its car lot across Main Street.

The centennial anniversary of the Battle of Lexington was celebrated in 1961. In the grand parade, this float, with Union and Confederate soldiers shaking hands in front of Harlan McKean, portraying Abraham Lincoln, won first prize. The reenactment, which drew about 20,000 spectators, was mainly fought by Wentworth Military Academy cadets. The crowd favored the South, which, to no one's surprise, won the battle, as it did in 1861.

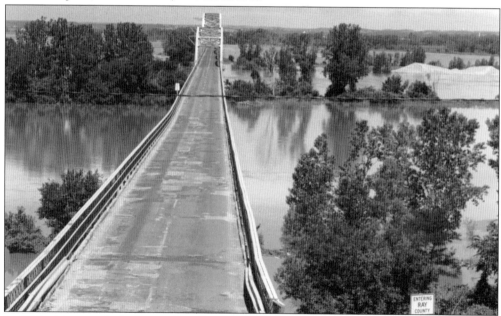

In 1993, visitors to the Lafayette–Ray County Bridge, who had to walk since the highway on the other side was underwater, got to see about five miles of water, as another terrible flood struck the area. The water company was flooded, so a beer company gave away water in cans. One person was killed when the bicycle he was riding ran off the bridge into the water and he drowned.

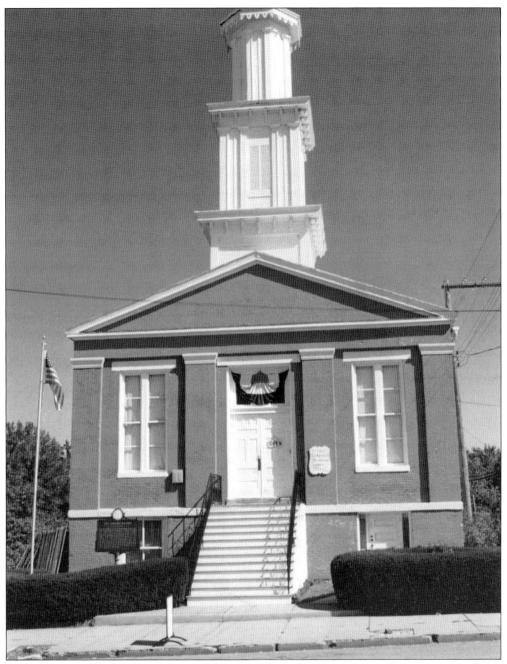

Built as the Cumberland Presbyterian Church in 1846, this structure was later a private school, the Evangelical Trinity Church, and the public library. It is now the Lexington Historical Museum and the Pete Schaperkotter Research Center. Exhibits emphasize the Osage Indians, the Pony Express, and the Battle of Lexington. The Lexington Historical Association has a large collection of historical photographs.

BIBLIOGRAPHY

Bell, Leslie H. *Educational Heritage of a Century*. Marceline, MO: Walsworth Publishing, 1962.
Continuing the History of Lafayette County, Volumes I and II. Higginsville, MO: Lafayette County Historical Society, 2002.
History of Lafayette County, Missouri. St. Louis, MO: Missouri Historical Company, 1881.
Lexington, Missouri 1822–1972. Lexington, MO: Standard Press, 1972.
A Pictorial Souvenir of Lexington, Missouri. Lexington, MO: *Lexingtonian*, 1912.
Sellers, Katherine Wilson and James V. Shannon Jr. *Historical Glimpses of Lexington, Revised*. Lexington, MO: Lexington Library and Historical Association, 1993.
Settle, Raymond W. *The Story of Wentworth*. Lexington, MO: Wentworth Military Academy, 1950.
Slusher, Roger. "Lexington and the Santa Fe Trail." *Wagon Tracks* (August 1991): 6–9.
Young, William. *Young's History of Lafayette County Missouri*. 2 vols. Indianapolis: B.F. Bowen and Company, 1910.

Index

apples, 2, 83
Aull family, 15, 19, 21, 45, 60, 71
Baptist churches, 22, 42–44
Battle of Lexington, 8, 25, 27–29, 32, 124, 125
bridges, 9, 15, 17, 50–52, 98–101, 124
Christian church, 19, 42
coal mines, 8, 33, 35–39
Daughters of the American Revolution (DAR), 9, 11, 12, 17, 101
Episcopalian church, 19, 94
Evangelical church, 49, 125
farmers, 58, 59, 60
fire department, 17, 79, 80
floods, 11, 78, 117, 118, 124
Goose Pond, 77, 85–90
Grand Opera House, 65, 66
hemp, 7, 18, 28, 32
Hicklin, James, 7, 13
Hoffman Brewery, 55, 67, 105, 106
Jack's Ferry, 14, 15, 16
James, Jesse, 30
Lutheran church, 98
Madonna of the Trail, 11, 101
Majors, Alexander, 8, 24, 72, 92

Masonic College, 7, 8, 27
Mattingly brothers, 10, 94, 120
McCausland, Susan, 11, 26, 32
Methodist church, 23, 46
Mulligan, James, 8, 27–29
Pony Express, 8, 24
Presbyterian church, 7, 19, 45, 49, 125
Price, Sterling, 8, 28, 29
Prohibition, 9, 103–106
railroads, 8, 33, 34, 35, 112, 117, 123
Rupe, Gilead, 7, 12
Russell, William H., 8, 24, 72, 92
Saluda (boat), 7, 19
Santa Fe Trail, 7, 17
slavery, 7, 8, 31
Spanish-American War, 8, 76
steamboats, 7, 8, 14, 18, 52, 84, 98, 99, 100, 114
Truman, Harry, 9, 11
Waddell family, 8, 15, 24, 43, 72, 92
Wentworth Military Academy, 9, 10, 13, 47, 48, 91, 103, 118, 119
Winkler family, 7, 40
World War I, 9, 91, 93
World War II, 9, 115

Discover Thousands of Local History Books Featuring Millions of Vintage Images

Arcadia Publishing, the leading local history publisher in the United States, is committed to making history accessible and meaningful through publishing books that celebrate and preserve the heritage of America's people and places.

Find more books like this at
www.arcadiapublishing.com

Search for your hometown history, your old stomping grounds, and even your favorite sports team.

Consistent with our mission to preserve history on a local level, this book was printed in South Carolina on American-made paper and manufactured entirely in the United States. Products carrying the accredited Forest Stewardship Council (FSC) label are printed on 100 percent FSC-certified paper.